MASTERING MANGA ART
WITH THE PROS

MASTERING MANGA ART

WITH THE PROS

TIPS, TECHNIQUES, AND PROJECTS FOR CREATING COMPELLING MANGA ART

Ilya Kuvshinov, Bobby Chiu, Ross Tran,
Svetlana Tigai, and Trung Le

DESIGN ORIGINALS

an Imprint of Fox Chapel Publishing
www.d-originals.com

©2023 by Future Publishing Limited

Articles in this issue are translated or reproduced from Manga Artist and are the copyright of or licensed to Future Publishing Limited, a Future plc group company, UK 2022.

Used under license. All rights reserved. This version published by Fox Chapel Publishing Company, Inc., 903 Square Street, Mount Joy, PA 17552.

For more information about the Future plc group, go to http://www.futureplc.com.

ISBN 978-1-4972-0639-7

Library of Congress Cataloging-in-Publication Data

To learn more about the other great books from Fox Chapel Publishing, or to find a retailer near you, call toll-free 800-457-9112 or visit us at *www.FoxChapelPublishing.com*.

We are always looking for talented authors. To submit an idea, please send a brief inquiry to acquisitions@foxchapelpublishing.com.

Printed in China
First printing

WELCOME TO

MASTERING
MANGA ART
WITH THE PROS

We all know that "manga" literally translates as "comics," but there's more to it in the ImagineFX universe. There's the traditional flat comic style, and there's the slightly more detailed, shaded and worked-up style. Then there's the highly textured, polished and painterly styles. No matter how broad the styles that fall under the term, there's one thing that unites all the art in this 148-page special. The majority of this volume is workshop based, and you can follow along on your own computer re-creating the amazing artwork with the help of our videos, but there are also features and interviews, sketchbooks and galleries galore, all to get you fired up to start making your own manga art. We aim to inspire you and help enhance your artistic arsenal by whatever means necessary (okay, maybe not whatever means). You can also find all the files you need to get re-creating the art in this book, grabbable from the ImagineFX blog. And ultimately that's the purpose of this book: to help you start creating your own manga masterpieces. No matter what they look like, the most important thing is that you have a blast creating them. Good luck!

CONTENTS

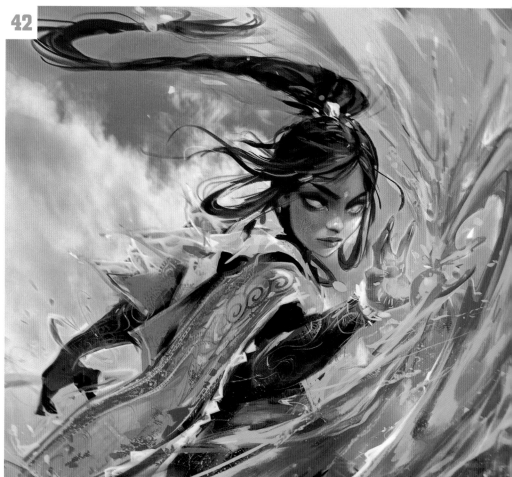
42

90

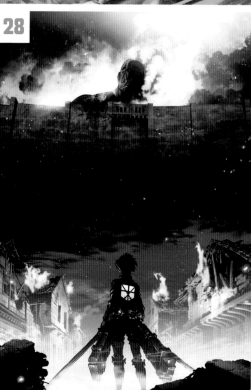
28

100

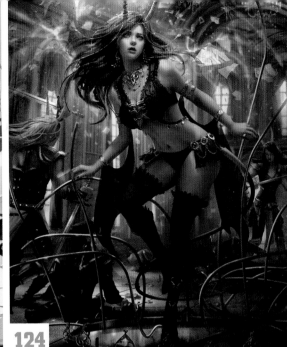

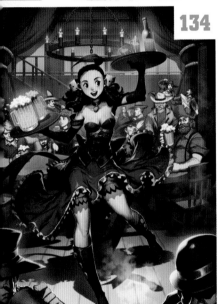

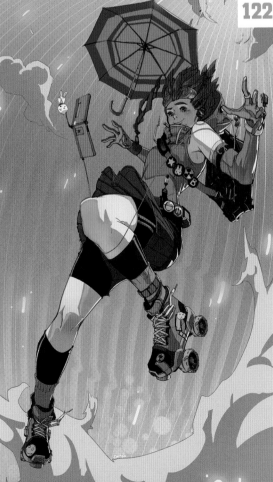

GALLERY
OUR PICK OF INSPIRING ARTISTS

EVA SOULU

LOCATION: Russia
WEB: www.evasoulu.com
EMAIL: eva.soulu@gmail.com
MEDIA: Painter, Photoshop, ArtRage

When asked what she does for a living, Eva always has the same response: "storytelling," she says. "Regardless if it's about a painting or a novel, story comes first."

Before beginning an illustration, she explores her characters and asks what's happened to them prior to the moment she's preparing to paint. This meticulous approach leads to an acute understanding of small details and mood, and creates a stronger impact.

"In the past few years I barely touched traditional media, but that's about to change," reveals Eva. "There's an amazing potential in mixing both digital and traditional mediums, and I'm eager to explore it."

1 LEADING YOU HOME "Here's Alesya, starship navigator from my sci-fi novel series. The first book, Vestnik, was published last year. I love to work on patterns and futuristic design – anything that requires detailed work feels like meditation and builds up focus. It goes well with coffee."

MANGA ARTIST SAYS

"Eva has a real eye for detail and polish, which combined with her use of bold graphic compositional elements makes her work eye-catching and satisfying. The muted value range in Metamorphosis is particularly effective."

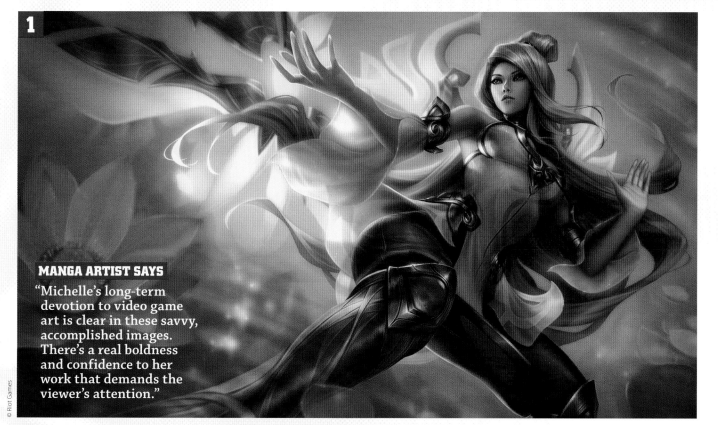

1

MANGA ARTIST SAYS

"Michelle's long-term devotion to video game art is clear in these savvy, accomplished images. There's a real boldness and confidence to her work that demands the viewer's attention."

© Riot Games

MICHELLE HOEFENER

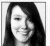

LOCATION: US
WEB: raingate.net
EMAIL: mhoefener@gmail.com
MEDIA: Photoshop

Michelle is an illustrator and concept artist working in the gaming and entertainment industry. She's been employed by companies such as Riot Games, Dynamite Entertainment and Cheesecake Girl LLC, and teaches at Riot Games studios in Santa Monica.

Now freelancing full time, Michelle recently worked on League of Legends illustrations and is also kick-starting her new project on Patreon, sharing her process and digital art tools.

"I love to create fantasy and science-fiction characters," she says, "working with color, light and materials to make each character come to life. Many of my illustrations feature beautiful strong women and dynamic compositions, poses and perspective."

1 ORDER OF THE LOTUS IRELIA "This is the splash illustration I did for Riot Games for the Order of the Lotus skin for the champion, Irelia, from League of Legends. I wanted to emphasize the tranquil, Zen, Chinese theme in this piece using vivid warm sunset lighting and colors."

2 SPIDER GWEN "This is a portrait of Marvel's Spider Gwen. I really love her design and colours and wanted to do a new take on her outfit. I also wanted to add close-up details to her face and hair, to create a more realistic aesthetic."

2

IQBAL BAIHAQI

LOCATION: Indonesia
WEB: artstation.com/iqbalbaihaqi
EMAIL: iqbalbaihaqi95@gmail.com
MEDIA: Photoshop

Currently in his third year in the visual art and design faculty at ITB, majoring in interior design, 20-year-old Iqbal started drawing digitally about five years ago, when his high school days "started to get boring".

A friend showed him the magic of digital painting and it drew him in. "I mainly draw fantasy or sci-fi themed artwork," he says. "It's inspired by film and video game concept artwork.

"I'm still struggling to work my way around digital painting, but I hope I will have a chance to work as a professional illustrator someday."

1 CHARACTER DESIGN : SRIKANDI
"A character design I made for a contest (which I unfortunately didn't win!). She's based on the Indonesian folklore heroine Srikandi, depicted as a powerful heroine wielding a bow and arrows with a clear-cut sense of justice. I decided that a twist in the design would be nice, hence the mecha armor!"

2 FALLEN ANGEL'S BRIDE "This is a re-drawn version of an earlier work to see how much progress I've made throughout the years. But I've changed so many things in the picture it's barely recognizable as a 're-draw' anymore. Even so, I'm quite satisfied with the result."

3 HUNT YOUR NIGHTMARES "Bloodborne! Words fail to express my love for the game. How they simplify something so convoluted into such a straightforward and insightful game is beyond me. Here I'm trying to capture Bloodborne's philosophy: less is more."

4 UNSEEN REGAL "A first successful attempt at drawing a large landscape. My friend gave me some pointers about giving an impression in a landscape painting. It worked like a charm and I'm quite happy with the result."

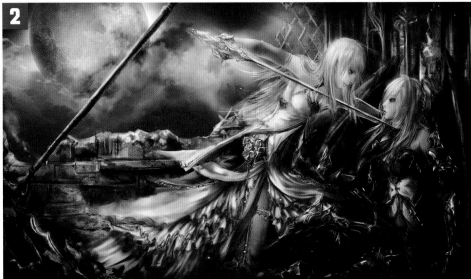

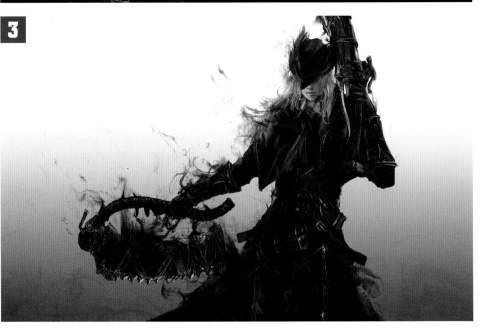

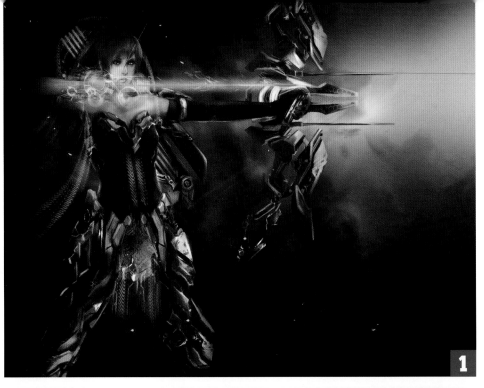

4

MANGA ARTIST SAYS

"Wow! Some impressive stuff here, Iqbal. We love the weapons and costumes, and the cool color schemes and sense of motion you capture. Great stuff."

1

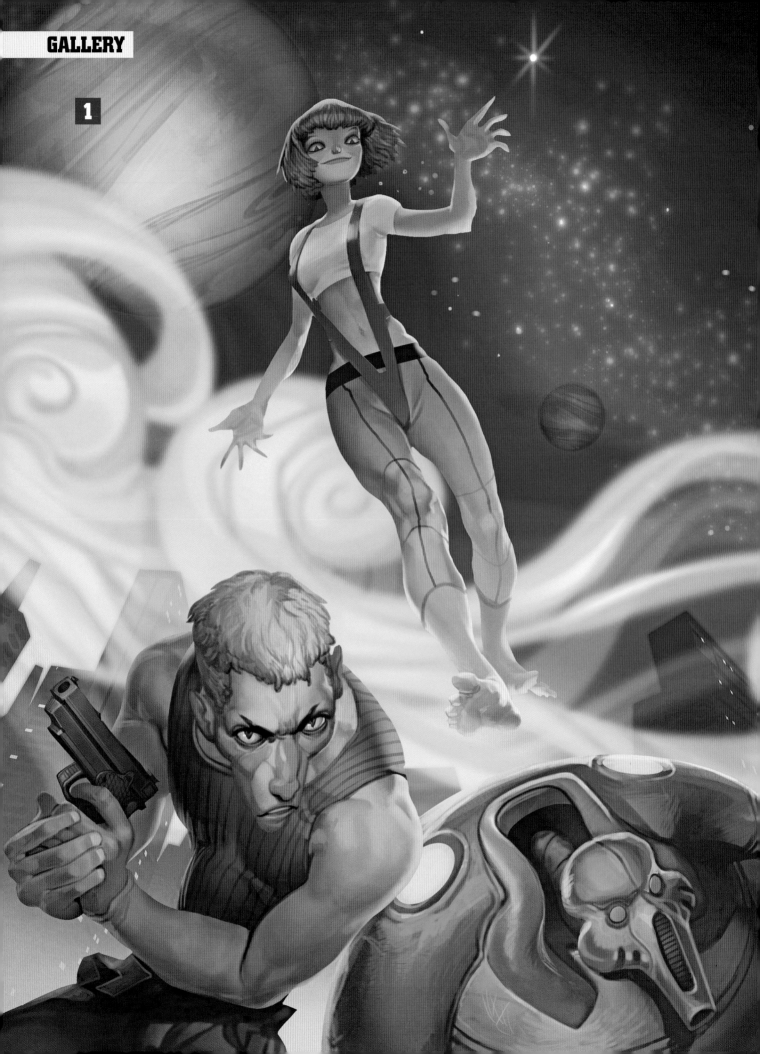

NADIA ENIS

LOCATION: Germany
WEB: www.nadiaenis.com
EMAIL: ideas@nadiaenis.com
MEDIA: Photoshop

The self-taught artist has worked for hire since 2008, which for the past six years has mainly been in the games industry, a field in which she also teaches.

"I've varied my style a lot in my career, fitting to briefings or target groups, and it never bothered me until recently," Nadia says. "Last year I felt the need to find my own home and decorate it. So I started a search for a visual language that can describe how I see the world.

"I'm still searching for my voice, or for the story that I want to tell. I've already found my personal guide, though. It seems to be humor."

Nadia is influenced by artists whose illustrations are windows into their inner world, such as the surreal power of Sergey Kolesov and the gentle elegance of Adam Tan.

© Paizo

1 5TH ELEMENT "This illustration was done for a fan-based artbook, which was successfully funded on Kickstarter. I wanted to try out a new mix of styles."

2 PATHFINDER "I was more than happy when Paizo commissioned me for half-orc characters, especially as they were women warriors. I'm weirdly attracted to this combination and had a lot of fun doing those. I grew fond of this lady in particular."

3 JINX "I started drawing in the manga style and even though I tend to be far away from it nowadays, sometimes I like to go back and visit this old friend of mine. Especially when doing fan art like this."

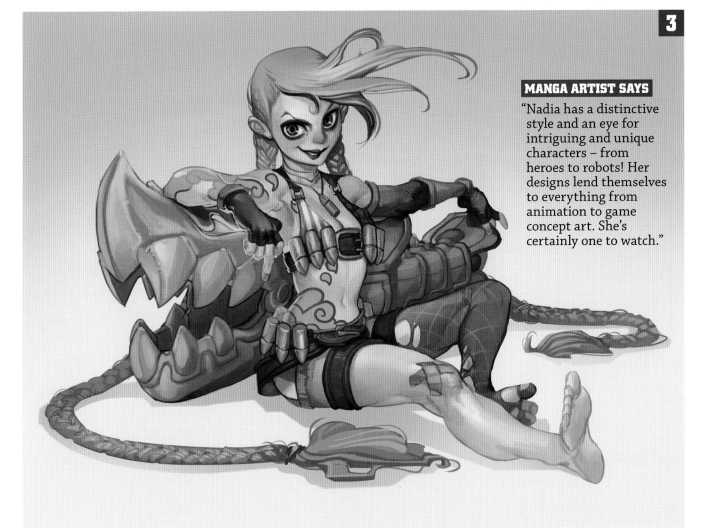

MANGA ARTIST SAYS

"Nadia has a distinctive style and an eye for intriguing and unique characters – from heroes to robots! Her designs lend themselves to everything from animation to game concept art. She's certainly one to watch."

AYYA SAPARNIYAZOVA

LOCATION: Turkmenistan
Web: artstation.com/ayyasap
EMAIL: animonika17@gmail.com
MEDIA: Photoshop

A few years ago, Ayya discovered the exciting world of digital art, and couldn't tear herself away. "I realized that it's what I want to do in life!" she says. "Digital art has enabled me to create without limits."

The artist likes to paint portraits and design characters, and in her work Ayya expresses emotions, feelings and moods through a characters's eyes, colors and lighting. "I take my inspiration from anime, computer games and films," Ayya reveals. "They've all helped to form my own style." She freelances, where she has a great scope for creativity: "You can learn a lot and work with interesting people!"

1 KATRINA'S MISSION "Sometimes I just like to paint new characters, such as this cosmic cat. Actually, she's part human, part cat, a big fan of adventure and very curious – like any normal cat! She's trained in martial arts and weapons, loves adrenaline and risk, and often gets into dangerous situations where escape seems impossible."

2 HARLEY QUINN "I decided to draw Harley Quinn because I like crazy characters – you never know what to expect from them! She's playful, armed and dangerous."

3 SUMMER SMILE "I love the sea, the sun and the beach. Here I wanted to capture this happiness in the girl's face, the wind blowing through her beautiful hair, and the warm light of the tropical sun. My aim was to recreate the atmosphere of summer for the viewer."

1

2

MANGA ARTIST SAYS

"Ayya's handling of light is exquisite, and she achieves the delicate balance between cartoon and realizm. Her colors and softly rendered images are rich in atmosphere."

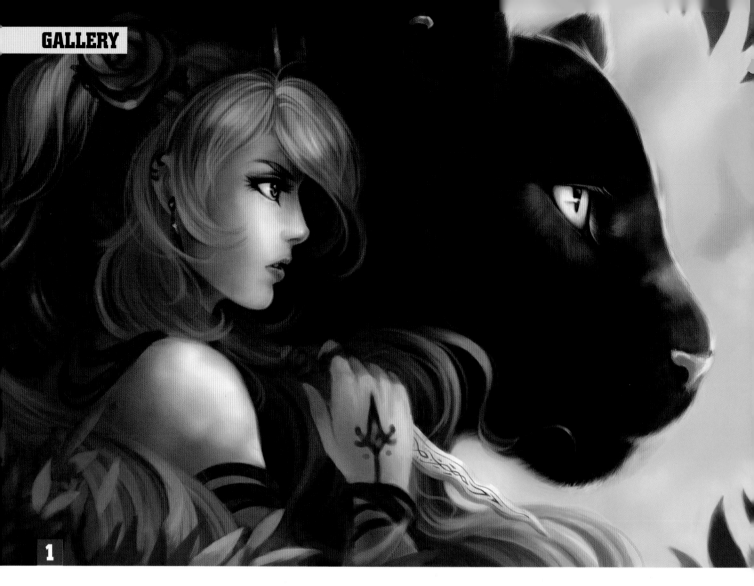

1

JODIE SNOW

LOCATION: England
WEB: www.laternaworks.co.uk
MEDIA: Photoshop

Jodie specializes in producing colorful paintings of women but has recently started exploring animal and landscape subjects in her art.

1 **THE HUNTERS** "I love painting pink hair. It looks especially lovely in bright green surroundings. This is a painting of my character and her panther on a hunt together."

2 **FOREST RINA** "Dense forest backgrounds are incredibly fun to paint. Just go nuts with a speckled brush and see what happens!"

3 **FOXCHILD** "Manga-style girls with animal ears are adorable. This one is like a fox spirit accompanying her kitsune friend."

4 **BIRD OF PARADISE** "For this image I wanted to paint something a little bit 'high fashion'. In particular I was inspired by various perfume ads in magazines."

2

3

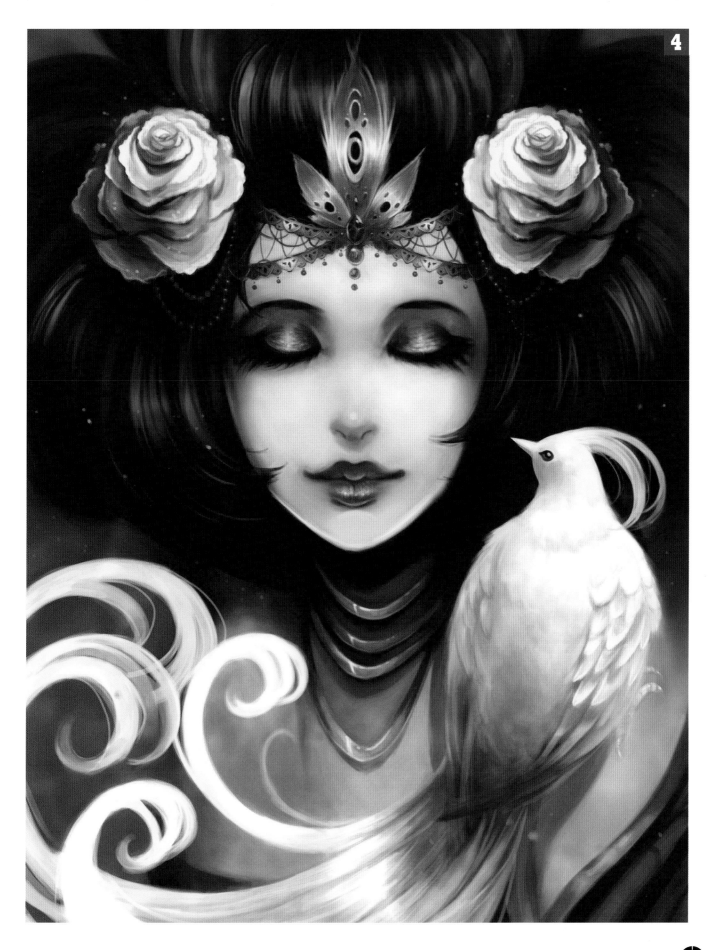

1

MANGA ARTIST SAYS

"Ursula is certainly able to place her characters in dynamic situations, matched with great colors and lighting. We love the effect of the flying shards of glass in her Berserker artwork – that was time well spent!"

URSULA DORADA

LOCATION: Brazil
WEB: www.sulamoon.com
EMAIL: sulamoon@gmail.com
MEDIA: Photoshop

Ursula began working as an advertising illustrator, but when Ubisoft made a call for artists for its studios in Brazil, she applied. "I worked there as a 2D artist for the brief period the studio operated in Brazil, igniting my passion to become part of the games industry," she says.

Making the move to freelance, Ursula now works for publishing and games companies. "I want to focus on fantasy, so I've been slowly working the more traditional finish into my work. As a kid who was raised playing D&D at the weekends, it's no surprise it's one of my biggest influences, along with video games such as Zelda and Warcraft."

1 UNDEAD PRIEST "The Warcraft series were a hit with my guild mates (yes, I still play it!), and my guild leader's birthday was coming up. I decided to paint her character as a gift, for all her hard work on keeping the guild going strong all these years. So this is her character, in her favorite set from the game."

2 ORC HUNTER "Here's a portfolio piece I created to build up my card games/Warcraft-style body of work. It's an honest Horde scout, complete with their most iconic bow and Orgrimmin flames. Now I need to work on an Alliance series, as soon as I have time."

3 BERSERKER "Here's an image for the game Ballistic, from Aquiris Game Studio. It's a class-based game, and each class has its own splash screen. This is my favorite from the bunch, and painting the broken glass was a fun challenge."

GALLERY

IAN OLYMPIA

LOCATION: Philippines
WEB: artstation.com/wickedalucard
EMAIL: coffeeflavoredpen@gmail.com
MEDIA: Manga Studio 4 EX, PaintTool SAI, Photoshop

"I've been working as an illustrator for 13 years now," explains Ian, who goes by the art name wickedalucard. "Most of the client illustrations I've worked on for the past years are for games and manga titles, and recently I've started working freelance in the hope of creating more personal projects."

Ian's dynamic work is heavily influenced by manga, anime, games and fashion, and he gravitates towards creating movement in his layouts. "I'm also fond of using pastel to saturate colors, and applying texture to my drawings," he explains.

When not painting up a storm, Ian says he likes playing the guitar, collecting art books and playing with his six adorable cats.

1 DELICIOUS HUNGER "Bird and Bearwolf – a pair of troublemakers from one of my fairy tales. These two were inspired by real people. The hidden treasure of stories is that even when the people disappear, the story remains, recovers and lives on."

2 LEADING YOU HOME "Here's Alesya, starship navigator from my sci-fi novel series. The first book, Vestnik, was published last year. I love to work on patterns and futuristic design – anything that requires detailed work feels like meditation and builds up focus. It goes well with coffee."

1

2

MANGA ARTIST SAYS

"Ian's use of delicate ornamentation, combined with low key colors and bold reds, make for exquisitely romantic-looking images."

GALLERY

ELVIN NEAL B. BERSAMIRA

LOCATION: Philippines
WEB: fb.com/ArtOfDexter
EMAIL: dexterbersamira@gmail.com
MEDIA: Photoshop, Clip Studio Paint

"My only formal art training was a six-month short course in 2D animation," says Elvin, also known as Dexter, "but after finishing my studies I realized I don't have the perseverance for animation," so instead he wisely put more effort into his illustration and manga skills. He now freelances as a 2D game artist and illustrator, for both local and overseas clients. "I'm also a contributing artist for The Philippine Daily Inquirer (2BU Lifestyle section) and resident illustrator for UnimeTV," he explains, making us wonder if he has any spare time!

While loving manga, he also admires the works of a variety of artists such as Noah Bradley, John Avon and Feng Zhu.

MANGA ARTIST SAYS

"Elvin's work has all the bright cheerfulness of the classic manga style combined with a richness of detail that really draws the viewer's eye into his paintings and makes them come alive."

1 HIGHWAY BLOSSOMS My guest art for the visual novel game Highway Blossoms (Steam Game) by Alienworks. In this illustration, I tried to emphasize the game's main characters, Amber and Marina, by using the background to give more focus."

2 MEGA CHARIZARD! "This is my fan art of Mega Charizard from Pokémon. In this illustration I tried to make Charizard encapsulated by the pokeball yet powerful at the same time."

3 MATSURI "An artwork commissioned by ASPAC-DAN ad agency. I was asked to create an illustration that evokes the Japanese culture, as their company will be under the new management of Dentsu Aegis Network. Therefore I decided to create this so as to celebrate Japanese Matsuri by featuring an elegant Yukata."

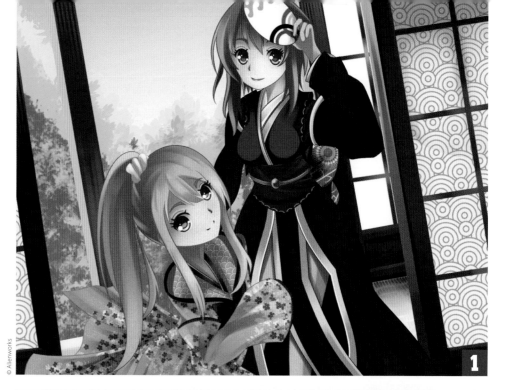

© Alienworks

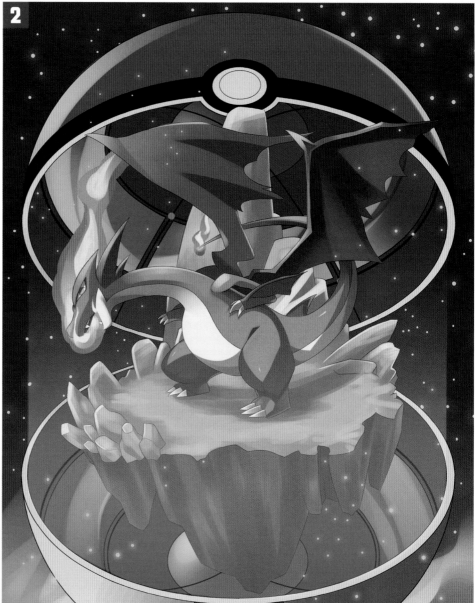

© Pokémon / Nintendo

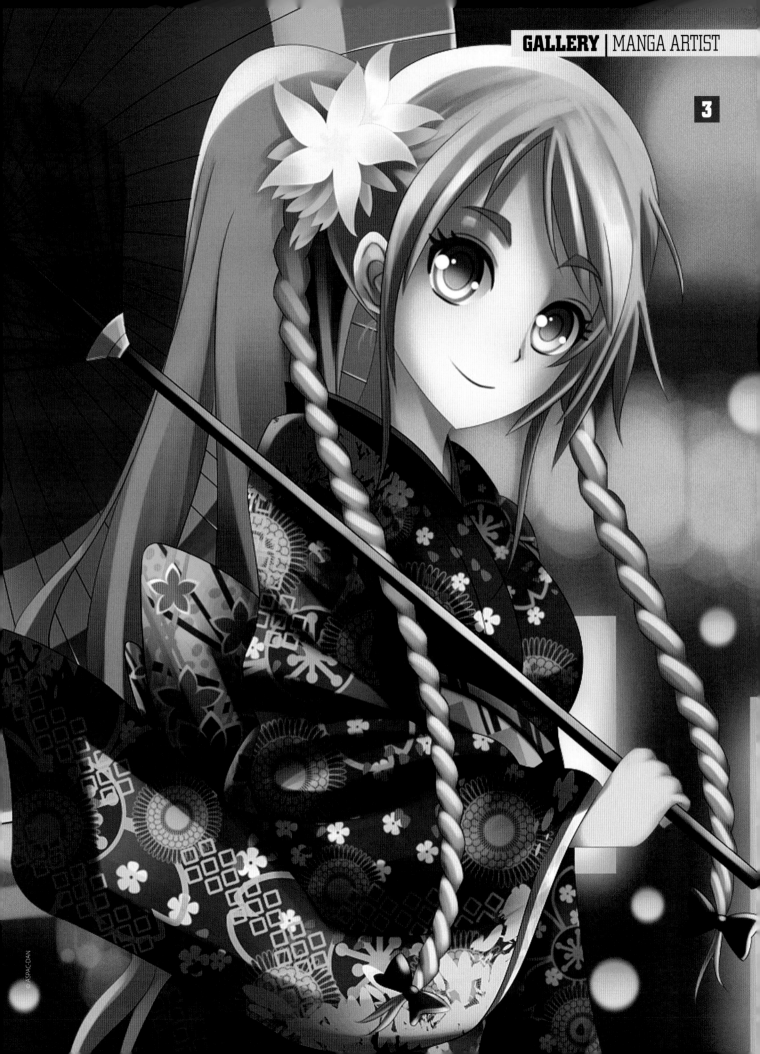

GALLERY

TRUNG LE

LOCATION: US
WEB: klegs.deviantart.com
MEDIA: Photoshop

Trung, aka Klegs, is a student in California. He started creating digital art two years ago, mainly because he wanted to paint fan art of his favorite characters.

1 PORT "I have little experience painting traditionally so I thought it would be interesting to reproduce watercolors digitally. It was a good learning experience."

2 UNDERGROUND CITY OVERVIEW "This piece follows a girl and her journey through many different landscapes. I've often thought about how beautiful cities would look if humans lived underground."

3 OCHAKO URARAKA "This was a fan art piece for the recent show called Boku Hero no Academia. The main goal of this piece was to get a bit more practice with a couple of watercolor digital brushes."

4 UNDERGROUND TOWN SHOP "This piece explores an underground city from another perspective. I focused on trying to convey the sense of exploration you feel when you're lost in music."

ANIME NOW!

How is Japanese animation holding up? We survey the field and find aging superheroes, hungry giants and Ping Pong champs...

Around a quarter of a century has passed since Neo-Tokyo exploded in Akira. That's when Japanese animation became a thing around the world, in that people became aware of it beyond a handful of fans. Many present-day fans will have grown up in that interval, getting into anime through Dragon Ball Z, Naruto, Death Note or Ghibli. In the same period, anime has evolved with new trends, styles and hits – although it's questionable to talk of hits in such a niche market.

Anime is niche, and has become even more so in the fragmented mediaverse of the 2010s. Most productions labeled "anime" abroad weren't made for Japanese cinemas or prime-time viewing. They were made for graveyard TV slots in the small hours, getting about 0.4 percent of Japan's TV audience. Even Naruto, which plays at 7:30 in the evening in Japan, would struggle to get 5 percent of TV viewers.

The only true anime blockbusters are some of Hayao Miyazaki's films released by Studio Ghibli. Spirited Away was Japan's top-grossing cinema release ever (domestic or foreign) for more than a decade after it opened in 2001. But Miyazaki has retired, at least from feature films. The same seems true of Ghibli itself, though Britain will presumably get the studio's last non-Miyazaki film, When Marnie Was There, based on a British kids' ghost story. In Japan, Spirited Away was supplanted as the top release by Disney's Frozen. Yet while anime is niche, it's not fading out. There's a huge number of new titles released every year – largely TV shows, often running 12 or 13 episodes. Many are rooted in the genres that were popular in anime 20 or 30 years ago. There are sci-fi and fantasy titles, often with big robots or magic girls; school comedies and rom-coms; and lurid horror. Other anime genres, like sports

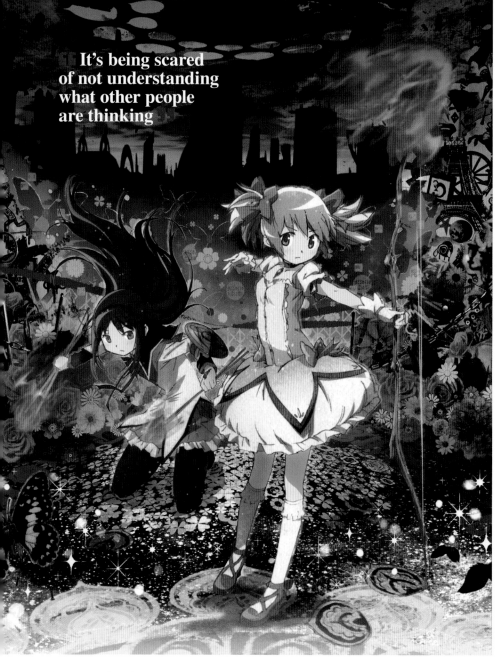

It's being scared
of not understanding
what other people
are thinking

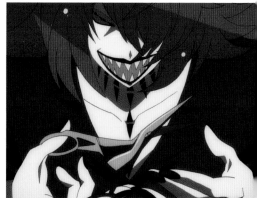

ANIME JOKER
Here's the villain of Gatchaman Crowds.
He's a version of the Zoltar baddie from
Battle of the Planets.

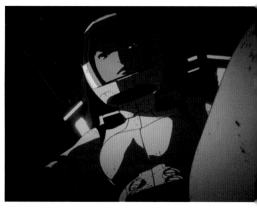

TRON LEGACY
Knights of Sidonia was made by the CG
studio Polygon Pictures, which also worked
on the TV cartoon Tron: Uprising.

◄ **DARK MAGIC**
Puella Magi Madoka Magica
begins like a children's cartoon
about magic girls, but it becomes
far darker and madder.

shows, are skipped by markets like Britain; a recent example is Yowamushi Pedal, about bicycle racing.

Look beyond the clichés
You can get annoyed with anime for the same reason you can get fed up with superhero comics, because of their endless recycling of motifs and clichés, both narrative and visual, and their common reluctance to step outside them. In terms of choosing subjects, anime often seems less bold than, say, Pixar or indie toons like Persepolis or The Illusionist. And yet, there are still remarkably bold anime.

Take Puella Magi Madoka Magica (don't be deterred by its indigestible name). It looks like a cutesy Sailor Moon kids' series with some unusually trippy artwork, about girls given magic powers by a catlike creature with a wide smile. And then it becomes a cross between Cabin in the Woods, Yellow Submarine and Faust, going darker, crazier and more heart-rending until its cosmic finale makes 2001: A Space Odyssey look small. "I was asked to write a bloody story where magic girls appear…" Madoka's writer Gen Urobuchi told the newspaper Asahi Shimbun. Actually, there's little blood in Madoka, just

anguish and torment, though Urobuchi later wrote the anime Psycho-Pass, in which a high-tech world is drenched in splatter-killings of the kind you'd see in Hannibal. But Madoka owes its visuals not to Gen but to Gekidan INU Curry (literally "Theatrical Company Dog Curry"), which is the pseudonym for two maverick animators responsible for the girls' extraordinary enemies.

In imagining these otherworldly demons, the artists went outside mainstream anime. Their limited, abstract, handmade cartooning

ANIME TIMELINE
**THE WEST FIRST BECAME AWARE OF ANIME
WITH AKIRA, BUT ITS HISTORY IN JAPAN GOES
BACK MUCH FURTHER…**

c. 1917
The earliest Japanese cartoons made by pioneering film-makers. For more on the origins of Japanese animation, track down Anime: A History by Jonathan Clements.

1945
The first full-length Japanese animation is Momotaro's Divine Sea Warriors. A propaganda film, it shows Japan liberating Asia and was released shortly before Japan's surrender in World War II.

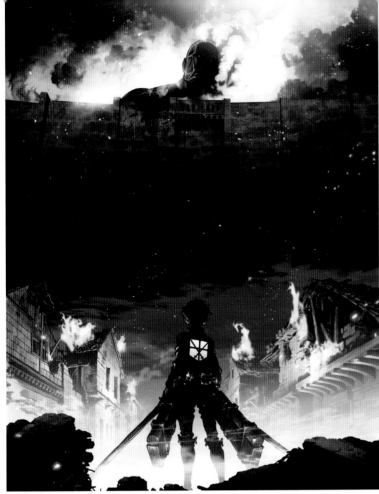

YEAR ZERO THE ANIME VERSION OF ATTACK ON TITAN MODELED ITS OLD-FASHIONED STONE CITIES ON ARCHITECTURE IN GERMANY.

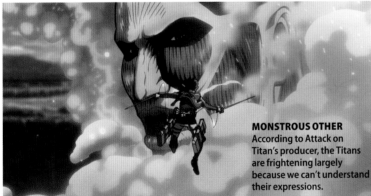

MONSTROUS OTHER
According to Attack on Titan's producer, the Titans are frightening largely because we can't understand their expressions.

GIRL DETECTIVES
The Case of Hana and Alice is about two kooky amateur detectives, who have previously been introduced in a live-action film.

ANIMATED LIVE-ACTION

Some new anime has gone back to one of the oldest animation techniques: rotoscoping

One of the more unexpected trends in recent Japanese animation is for some titles to use old-fashioned rotoscoping, where live-action film is painted over to create non-cartoony animation. (An American example is Ralph Bakshi's animated Lord of the Rings from 1978.) The TV serial Flowers of Evil uses rotoscoping to moody, menacing effect, telling a story of teen bullying and obsession in a small town. The feature film The Case of Hana and Alice is far more benign, a kooky comedy-drama in which two teen girls investigate a rumored murder. It's a prequel to a live-action film from a decade earlier, simply called Hana and Alice.

POISONED FLOWERS
Flowers of Evil takes its title from the French poetry of Charles Baudelaire.

has touches of art animators like Czech surrealizt Jan Svankmajer. One savage battle, played out in black silhouettes, feels like an homage – though a violent one – to the female animation pioneer Lotte Reiniger. "We both had set our eyes on Russian and Czech animation styles," explain the duo. "Rather than working with a lot of people like in an orchestra, we prefer to create miniature landscapes that can be accomplished by working individually." Madoka Magica is disturbing, but the dominant anime horror is Attack on Titan, effectively a zombie holocaust apocalypse drama. The twist is, these zombies are Godzilla-sized giants, besieging the last humans in a stone city. Producer George Wada argues that Titan taps the fear of the Other. "It's being scared of not understanding what other people are thinking. The Titans look like they're smiling, or sad, but the fear comes from not understanding what those expressions mean."

Titan is a grisly, morbid blend of Romero, Lovecraft and Akira. Unlike Madoka Magica, it was based on an already successful manga series by the young artist Hajime Isayama.

1963
Astro Boy, which featured a Pinocchio-like robot boy, is one of the first Japanese TV cartoons. Both the cartoon and the original manga were created by Osamu Tezuka, the so-called God of Manga.

GLASSES GIRL
Subverting convention again, this benign-looking Madoka Magica character is actually one of the scariest in the series!

PEPSI PINUP
Tiger & Bunny envisions fully corporatized superheroes
– the heroine Blue Rose stars in adverts for Pepsi Next.

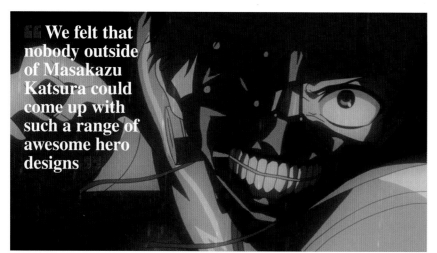

> **We felt that nobody outside of Masakazu Katsura could come up with such a range of awesome hero designs**

BEAST BOY
The horror series Tokyo Ghoul involves an
ordinary boy who's transformed into a
flesh-eating monster.

ODD COUPLE ▶
The title characters of Tiger & Bunny
– surprisingly, the bearded, middle-
aged Tiger was the more popular.

"We have been very faithful to the manga, but the anime looks different; there's a difference in the expression of the manga and the anime," Wada says. For example, the human city looks more European in the anime; the staff studied material from Germany.

Embarrassed by giant zombies

On the manga side, Isayama is famously diffident about his work, saying he is "really embarrassed" about the weaknesses he perceives in his strip – especially the first volume, "when I see my drawing and I can't follow the storyline." He even suggests that the Titan anime

should be considered the definitive version of his story. The first Titan anime was made a couple of years ago, with a continuation due later in 2016. A two-part live-action film was made in Japan, but was widely panned; there's also a silly spoof anime series, Attack on Titan: Junior High. Other horror titles have risen in the meantime, including Parasyte – The Maxim, Tokyo Ghoul and (recently in Japan) Ajin. All three revolve around young protagonists who get turned into inhuman creatures and thrown into ambiguous wars where humans may be the monsters.

Away from horror, the cheerier Tiger & Bunny is a superhero comedy-drama, set in a futuristic metropolis where caped crusading is corporatized. The heroes

1968
Star of the Giants, about a baseball player, is the first sports anime series. The genre has been popular with audiences ever since, with episodes about everything from boxing to basketball.

fight evil on live TV, competing for audience shares, in suits covered with company logos. The show's best idea is to focus on a fading hero (Tiger), a middle-aged widower who's unwillingly paired with a photogenic youth (Bunny). Unusually, Tiger has a beard, which was risky in Japan: as producer Masayuki Ozaki explained, "Japanese women do not feel attracted to men with facial hair." But it worked – Tiger was a hit with female viewers. The heroes were designed by a famed manga artist, Masakazu Katsura, whose strips include Video Girl Ai and I's, both centerd around pretty girls. But executive producer Ozaki told the magazine Weekly Shonen Jump that Katsura was a superhero fan. "We felt that nobody outside of Katsura could come up with such a wide range

AFTER MIYAZAKI

Hayao Miyazaki has retired, Ghibli seems to be ending… Can anything take their place and match their successes? We examine the evidence

For some pundits, the question "Who is the next Miyazaki?" is as wearisome as "Why do anime characters have big eyes?" Anime expert Jonathan Clements, author of the indispensable Anime: A History, argues that Hayao Miyazaki was simply unique, as was his artier mentor Isao Takahata (Princess Kaguya) and the Ghibli studio they co-founded.

However, if you're looking not necessarily for a new Miyazaki, but just for anime with a similarly popular touch – accessible to mainstream, international viewers, with a sense of poetry and wonder – then there are candidates. In recent years, there have been some excellent anime movies that feel Ghibli-esque without being imitations. One is Patema Inverted, in which a girl discovers an upside-down world where she's in constant danger of plunging into the sky; another is Giovanni's Island, a fantasy-tinged history drama about two boys on an island occupied by Russia in the 1940s.

But the big directors often compared to Miyazaki are Makoto Shinkai and Mamoru Hosoda. Shinkai first came to attention with a short film, Voices of a Distant Star, which he made practically solo. He's since developed sumptuous feature films, such as 5 Centimeters per Second, which are often themed around love-struck teenagers. His 2011 Journey to Agartha looked great, but failed to build a world as compelling as Miyazaki's. Far better was 2013's Garden of Words, a 46-minute intimate drama about a boy and a woman meeting in a Tokyo park in Japan's rainy season.

Using digital tools

The rain is a key element of Garden of Words. "The droplets of rain in the air are particle simulations," Shinkai explains, "and the rain splashing in puddles and in lakes, the ripples, the spray, that's hand drawn." Rain was an important part of Ghibli films such as Totoro and Kiki's Delivery Service. "I was impressed by their use of rain, but they were made in the days of analog… I wanted to see if I could make the rain in Garden of Words look as impressive using the computer."

However, it's Mamoru Hosoda who's the hottest name in anime at the moment. Notoriously, he was hired by Ghibli to make Howl's Moving Castle, only for his version to be rejected. Since then he's made his name through his own outstanding feature films, with winning characters and strong themes: The Girl Who Leapt Through Time, Summer Wars and The Wolf Children. Hosoda's latest film in Japan is The Boy

and the Beast, which has elements of Spirited Away and The Karate Kid. A boy finds a world of talking, brawling animals and becomes apprenticed to a bear-like bruiser.

At the recent Tokyo Film Festival, Hosoda said: "When I have an idea in my mind, I can't help thinking about how I can express it, how can I make it wonderful, to make people laugh. It's the sheer pleasure of making it happen that drives me through making the film." He says The Boy and the Beast was inspired by the birth of his son. "I'm thinking as a parent, how is he going to grow up, how are we going to raise him? Is he going to be able to find a soulmate or some master from whom he can learn about life?"

TOKYO LANDMARK
The action of The Boy and the Beast shifts between a fantasy world and the real-life Shibuya district in Tokyo (pictured).

◀ **CHILDREN'S HISTORY**
The many simplified backgrounds seen in Giovanni's Island were created by an Argentinian artist, Santiago Montiel.

RAINY SEASON
Rain is the central image in Garden of Words, the rain effects created both by hand-drawing and CGI.

1972
Science Ninja Team Gatchaman stars a team of heroes in birdlike costumes. It was a likely influence on the live-action Rangers shows in Japan, later brought to the West as Power Rangers. It was also adapted into the English-dubbed Battle of the Planets.

1979
Mobile Suit Gundam is a space opera in which soldiers pilot giant robot suits. It launched a huge franchise, with new Gundam anime still being released today. The original Gundam serial has just debuted on UK Blu-ray, courtesy of Anime Limited.

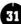

1988
Katsuhiro Otomo's cinema film Akira is a lavish, violent urban sci-fi epic, with biker gangs and superpowered teens. It marked the first time anime was recognized in the mainstream Western media as anime, although it was commonly mislabeled 'manga.'

CGI IN ANIME

Will there ever be an anime that achieves the success and widespread acclaim of Toy Story?

Over the past two decades, there have been regular attempts to make all-CG anime, often (though not always) aimed at the world market. Some are enjoyable – we recommend the sci-fi action film Appleseed Ex Machina – and some woeful, such as Appleseed XIII, another version of the same property. The 2013 CG film Stand By Me Doraemon remade a beloved trad toon about a friendly robot cat; it was successful in Japan, but isn't likely to challenge Pixar in foreign markets.

The CG studio Polygon Pictures has made some ambitious recent productions, including Ronja the Robber's Daughter (a children's show co-produced with Studio Ghibli) and the horror-themed Ajin: Demi-Human. Polygon's space opera serial Knights of Sidonia is available in Britain.

SPACE DEFENDERS
In Knights of Sidonia, the young heroes defend a giant spaceship carrying the last humans.

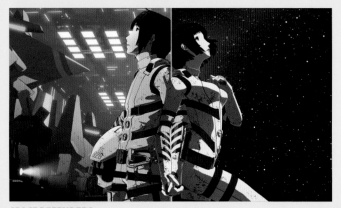

SUPER TOMBOY
The teenage Dragon Kid is the youngest of the superhero characters in Tiger & Bunny, and the only Chinese member.

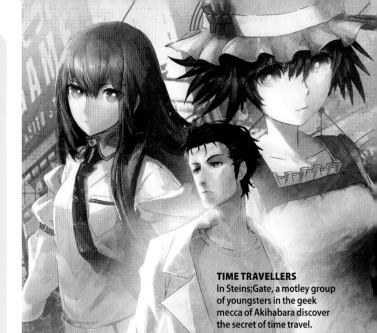

TIME TRAVELLERS
In Steins;Gate, a motley group of youngsters in the geek mecca of Akihabara discover the secret of time travel.

SCISSOR SISTER
In the hyper-manic, hyper-cartoony Kill la Kill, a girl warrior has her power boosted by her sentient, blood-drinking school uniform!

of awesome hero designs… To him, this project was a surprise because most clients who approach him usually ask him to design cute girls. We were the first team to ask him for hero designs. So he kept asking, 'Seriously? You chose me?' We wanted him to draw cute girls too, but we mainly wanted him to draw heroes."

Tiger & Bunny is now being developed as a live-action Hollywood film co-produced by Ron Howard, who calls it "a great buddy story." In Japan, Tiger & Bunny has been followed by more eccentric hero anime, such as Samurai Flamenco, a show which begins like Kick-Ass and then becomes closer to Monty Python. Another series, Gatchaman Crowds, features a cheery heroine, campy silliness, knotty politics, social networks and an eye-scorching color scheme. The word Gatchaman tips the hat to a seminal 1970s anime of that name, recut in the west as Battle of the Planets. Away from the usual hero shows, the outstanding Steins;Gate is about ordinary youngsters – or at least ordinary eccentrics – who are conducting research into time travel in Akihabrara, Tokyo's geek mecca of computer stores and maid cafés.

The serial's first half blends sitcom and conspiracy drama, then the show transforms into a white-knuckle thriller and time-travel drama that

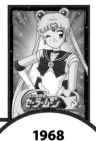

1968
Star of the Giants, about a baseball player, is the first sports anime series. The genre has been popular with audiences ever since, with episodes about everything from boxing to basketball.

1968
Star of the Giants, about a baseball player, is the first sports anime series. The genre has been popular with audiences ever since, with episodes about everything from boxing to basketball.

1968
Star of the Giants, about a baseball player, is the first sports anime series. The genre has been popular with audiences ever since, with episodes about everything from boxing to basketball.

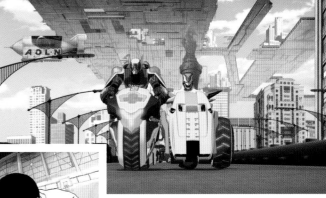

MAGIC PRINCESSES
Magic Girl heroines like those in Madoka Magica have been a staple of anime since the 1960s.

BIKER GANG
Tiger & Bunny uses some specifically Japanese superhero conventions, such as the tendency for heroes to ride motorbikes.

◀ **PLAYING FREESTYLE**
Masaaki Yuasa's Ping Pong has some of the most unusual artwork in a commercial TV anime.

puts Doctor Who to shame. Based on a so-called visual novel (a computer game where you choose your way through a branching storyline), the show will be followed by a quasi-sequel, Steins;Gate 0, depicting one of the story's alternative timelines.

Conveying the joy

The last word should go to two graphically dazzling series. Ping Pong, unusually, is a sports anime getting a release in Britain (you might have seen a live-action film version of the same Ping Pong manga, using Matrix-style effects). In the animation, characters move in loose, idiosyncratic ways; there are crazy pavings of split screens; and yet it's also a heartwarming comedy-drama. "I want to see more relaxed

animation coming from Japan," Ping Pong director Masaaki Yuasa told twitch.com. "Animation where everything is not perfectly drawn. The strict way it looks now, it sometimes seems like working on anime is more pain than pleasure! I prefer to have joy in making animation." A similar spirit animates the manically bonkers-on-a-jetpack Kill la Kill, where a girl with giant scissors and a vampiric talking sailor suit takes on a massive fortress-academy and its superpowered staff. Space and time bend like a Looney Tunes toon, but with more orgasmic explosions. The show is by the same team as Gurren Lagann, a mad mecha show from a decade ago. Its makers have now formed their own outfit,

Studio Trigger. One of the Triggers, Shigeto Koyama, was asked what distinguished anime from American animation. "I feel that Japanese animation is more complicated, more fetishistic," he said, "and that there's more division into different art styles, more of a need to continually come up with new ideas."

He admitted, though, the downside to this creative splurging: "It makes it a little bit hard for ordinary people to understand and follow sometimes." ∎

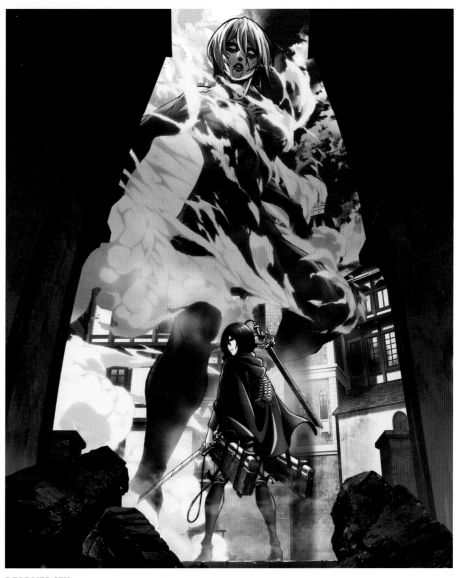

DEADLIER SEX
This sultry female giant plays a central part in the second half of the Attack on Titan anime.

ASTRO BOY

FOR A NEW GENERATION

Osamu Tezuka's classic Japanese manga Astro Boy sprang into action in three dimensions on the big screen in 2009. We look back at that adventure as Imagi took the 2D character and breathed 3D life into him...

FILM FACTFILE

Title: Astro Boy
Web: astroboy-themovie.com
Released: October 2009
Estimated budget: $40m
Box office: $41.6m
Lead studio: Imagi
Project duration: 2.5 years
Team size: 300-400
Software used: Maya, modo BodyPaint, ZBrush, RenderMan

Astro Boy was created in 1952 by Osamu Tezuka, who is widely called "the god of manga". The anime series became popular in Japan in the 1960s and today Astro Boy is a cultural icon, so it's with great care that director Jakob Jensen began work on the 3D film. The production company Imagi – which has offices in Hong Kong, LA and Tokyo – was charged with creating a 21st-century update of the atom-powered hero.

Challenges came fast. "We first tried to do a direct transfer from the original 2D Tezuka design over to 3D while updating Astro's look to fit the story the director wanted to tell," says art director Jake Rowell. "But while we captured the essence of the original design, it lacked a level of sophistication found in the original."

The decision was taken to design Astro in 3D. "We approached the 3D design process similar to building a maquette, putting shapes together that built an appealing form," Rowell explains. "Through this process [we] could more easily experiment with the look of various ages, and develop facial expression sheets by drawing directly over the 3D sculpt. "By doing the bulk of the design in 3D," Rowell adds, "we were able to take those notes into ZBrush and mock up some deformations and facial poses to show the design principles. We then exported it into Maya for a final clean-up pass."

Once the Astro Boy model was rigged, it was ready for animation. Tim Cheung, head of animation, oversaw the keyframed animation, making pipeline improvements such as the development of a slider-based blend shape facial animation system that sat

on top of Maya and offered the animators hundreds of controls.

The vast, cluttered landscape known as the scrap heap was considered the most difficult technological task in the film. "The scrap heap was where we had literally millions of robot parts, strewn together to form a landscape which recedes from one end of the horizon to the other," says visual effects supervisor Yan Chen. "The theory was that Metro City, floating above the Earth, would discard old robots and parts by bulldozing them off the edge of the city to fall to the surface below. The discarded plastic and metal debris would collect in gigantic spires rising up from the ground.

"To build this with conventional technology would have taken years and years," explains Cheung. "To model the spires along with all

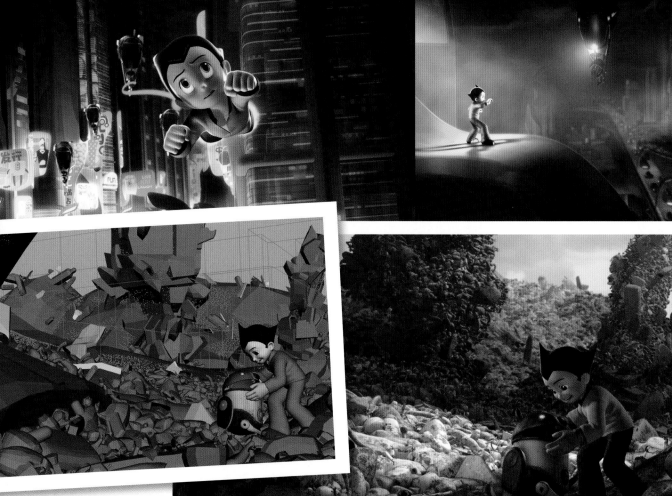

BIG ISSUE
The scrap heap scene, with millions of robot parts strewn across a vast 6 miles wasteland, presented Imagi with its biggest technical problem.

> **" Render times were really fast because of all the instances. That allowed us to get literally millions of robot pieces scattered through the landscape "**
> Tim Cheung, head of animation

the rolling hills would have been impossible, so we just modeled terrain, forms that represented the shapes and volumes we were looking for. Then we had to write code that achieved the look but didn't kill us either in build times or rendering times."

Scrap heap challenge

The scrap heap was primarily designed and staged in 3D using previs to block out the entire location while setting cameras for the main action. Chen's team could then focus on

the details of the given area versus trying to achieve the entire location in 3D.

Using Maya and a particle instancing system, they were able to fill the landscape with approximately 50 combinations of 30 to 40 robot parts and spread those across the landscape. However, 30 pieces spread over 6

miles resulted in an overly uniform look due to the lack of color variations.

"We applied large-scale procedural maps that attenuated all the colors," says Chen. "Then the artists fine-tuned the rust and diffuse color levels, clamping down the specularity when things were too bright,

Astro Boy Flight Path

Osamu Tezuka, "the god of manga," had enormous impact on Japanese culture, and Astro Boy is his most famous creation

1928
Osamu Tezuka is born
Astro Boy's creator is born 3 November in Osaka, Japan. By his second year of school, he began drawing comics. He eventually qualified as a doctor, but his love of drawing drew him back to manga.

1951
Tetsuwan Atomu is created
Tetsuwan Atomu (literally "mighty atom") makes his first appearance as one of the characters in the manga Atomu Taishi. The large eyes were inspired by American cartoons, particularly Betty Boop and Mickey Mouse.

1952
Humanising Tetsuwan Atomu
The character lacked human-like qualities and wasn't particularly popular at first. When an editor encouraged changes that included humanized characteristics and a family, he quickly became a hit with children and adults alike.

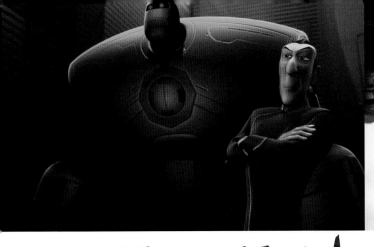

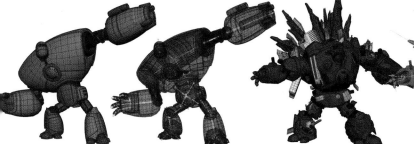

GROWING PROBLEM
The Peacekeeper's ability to absorb weapons and machinery proved problematic for the Imagi team: all three iterations of the character had to be carefully rigged to achieve clean deformations.

so they had artistic control that was global over the entire 6mi landscape."

In order to keep the render times to a minimum, the debris was designed to go from particle instancing to geometry instancing, all the way to hero geometry as the camera moved closer or further away. The objects could also deform and move with full interaction as the characters walked through the piles of rubble, so the characters could run through, kicking up pieces of robot parts without issue.

Astro Boy's final battle is with the Peacekeeper, a robot invented as a weapon to dominate Earth who magnetically attracts bits of his environment and integrates them into his form, growing larger as he adds bulk. His adaptive technology can absorb other technology and use it against other weapons

or threats. As he grows and absorbs the technology around him, his body structure becomes more menacing, more monster-like.

The Peacekeeper goes through three stages: in the first, he's around seven feet tall; in the second, approximately 20; then in a third he is a gargantuan robot about the size of the Empire State Building. By the last iteration he is covered with pieces of monorail trains, lamp posts, buildings, all sorts of debris jutting from his body at all angles. But as he moved, the debris attached had problems of intersecting, presenting the animators with some rigging and deformation challenges.

"To solve this we put soft metal deformers all over the character and actually slid metals against each other using set driven keys,"

explains Chen, "but kept the objects as rigid as possible so he still felt metallic. The sliding against each other helped to hide any penetrations that resulted from the animations."

Keeping the peace

The second challenge was how to "represent his growth from each stage to the other without killing ourselves technically," to show the basis for the growth but not have to laboriously render the final coalescing of pieces that caused the Peacekeeper to grow.

"We used effects to bind the pieces onto his body through texture maps that would give some kind of transition," says Chen. "And we used hand-adjusted procedural textures for the super-close-up shots. After

1959
Fuji Television releases TV show
A live-action television series is the first adaptation of Tetsuwan Atomu. It is rumored that the character was influenced by Bambi, which Tezuka saw 80 times.

1961
"The Hot Dog Corps"
A bizarre 170-page epic, which became a classic of its time. The storyline involves space travel and giant robots, and the battle between good and evil.

1963
Astro Boy flies in US
Twelve years after the comic book series was introduced, Tetsuwan Atomu begins its first run on Japanese television. 193 episodes are produced. It also airs in the US under the name of Astro Boy.

1965
Condemning the arms race
"The Greatest Robot on Earth" is one of the best remembered tales – and it makes a great social comment: the climax features two robots unable to save their creators because they were designed only for battle.

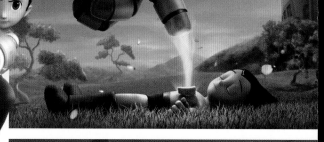

GROWING BOY
A progression showing Astro Boy from wireframe to subdivided mesh, to textured and fully lit and rendered.

SPARK OF LIFE
Zog is a robot that Astro Boy brings back to life. The hulking droid returns the favor at the end of the film.

the process of melding, the Peacekeeper was simply moving with the pieces embedded in him, and that was when we would use rigging to achieve clean deformations." Chen likens the process to the real-world example of a bowling ball smashing into a piece of clay: that clay would deform and end up with an edge around the resulting indent that is soft and a little nebulous. "This was achieved with quite a bit of expense in effects. But we wouldn't do that across all the shots – we would choose certain shots and cut away, and in the next shot the Peacekeeper would simply appear larger."

The rigging played an important role. To achieve the change in size and shape, Imagi designed the Peacekeeper as three distinct characters rather than creating a rigging process to turn the first iteration into the second and third iteration. Instead, the first was rigged to partially become the second, and transition shapes were added to represent the growth and absorption of material. The

> ❝ **The Peacekeeper was challenging. He had so many pieces sticking out, it was difficult to get clean deformation – so we cheated** ❞
>
> Yan Chen, VFX supervisor

second-stage character was rigged to partially become the third. By designing the first, smaller version and the last monstrous version, they could design the middle stage and the transition points.

Imagi also had FX shots to help blend those transitions further than the model and rigs could achieve. "If we had a key shot or close-up, that's where the FX department would kick in. They would add various beams or building shapes that are coming out of the Peacekeeper so you could see them grow or see them being absorbed into the massive shape of the robot," says Chen.

Because the Peacekeeper just has a jaw hinge, he has limited facial expressions. The animators needed to find another way to show his emotions, so turned to the red core power source located in his chest.

"We surfaced out the radial glow emanating from the center of his body and baked those to 72 frame cycles," says Chen. "We backed out the frames with a fairly narrow band of color. Then in Lighting we looked at the animation, determined how angry or excited he was, then used animation controls to dial the speed up or down, so the 72 frames would drop to 24 frames to

1966
Astro Boy gains a sister
Astro Boy gets a little sister for his birthday in "The Strange Birthday Present". Named Uran (or "Astro Girl" in the US), she first appears in Episode 25 of the original black-and-white television series.

1981
Australia's Astro Boy in color
A new full-color version of Astro Boy is created for a TV series; over 52 episodes are produced. The series airs on Australia's ABC Network.

1989
Osamu Tezuka dies
In Japan on 9 February Osamu Tezuka dies of stomach cancer. During his lifetime he completed over 150,000 pages of manga art and 60 animated shows.

1994
Osamu Tezuka Manga Museum opens
In his hometown of Takarazuka, the Osamu Tezuka Museum opens. Tezuka remains the most legendary animator in Japanese history, but never received quite the same recognition in the US.

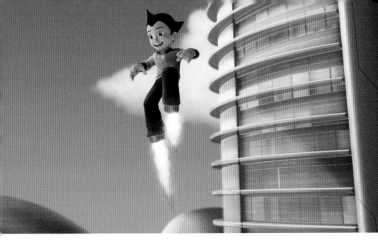

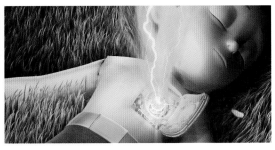

Trashcan is new to the Astro Boy canon, designed specifically for the movie.

PROUD MOMENT
With their rich mix of textures and effects, the climactic final scenes are visual effects supervisor Yan Chen's favorites.

simulate a heartbeat. As he got more excited, we increased the speed and playback of those textures." The result was a heightened sense of urgency, and the addition of another emotional level component, which was tied with Animation to Surface to Lighting.

At the end of the film, Astro sacrifices himself for the good of the world. The story culminates with the rebirth of Astro as he's brought back to life by Zog, a robot to which he gave life earlier in the film. There's a choreography of elements brought together to form the final emotional climax as Zog returns the blue energy that Astro Boy lent him. As Astro lies lifeless in a field of grass, the energy swirls around him.

To create the look of those final moments, when Astro and his father are reunited, Chen focused on gently intermingling the swaying grass, cherry tree branches and falling petals with the mystical blue energy. It was a process where story, art direction and technology all came together to form the denouement of the film. For Chen, this was his favorite scene. "That was probably one of the most proud moments working on the show," he says contentedly, "seeing everything hum and coalesce together for the final moments." ∎

TRASHCAN: THE METALLIC MUTT

The movie's scene-stealing comic relief is a robot dog belonging to Astro Boy's friend Cora

Trashcan is a robot dog with a simple design but a clever twist. Upright, Trashcan sports small, somewhat static legs on wheels attached low in the front, with back legs hinged high just behind where a shoulder joint would normally be. The back legs are rigged to drive forward movement, but when Trashcan needs to get his nose to the ground to sniff and hunt, he simply leans forward. His hind legs – with a pivot point just below the head – automatically move forward with him, paws rotating 45 degrees towards the ground. It's a simple but elegant solution that results in a bouncy, very dog-like movement while still retaining robotic overtones.

The design didn't start out that way: originally he was designed with leg placement closer to a conventional dog. But head of animation Tim Cheung noticed how often traditional cartoon bulldogs would have large front legs and small hind legs, making the front appear muscular and meatier and therefore more aggressive, ideal for scenes that required that behaviour. "We figured we could actually use the front legs as shoulder joints in addition to hip joints at the back. That was a little bit of a rigging challenge where we have the two modes for the dog. So if we wanted him to run like a bulldog, we would pull the bottom half back, and if we wanted him to run like someone pushing a lawnmower, we would simply pull the top half back."

While mouth movements were handled by simply flapping Trashcan's lid, this wasn't enough to portray the range of facial expressions needed. By adding the capability for the head to swivel, and even detach slightly from his body, the animators gained far more expression through posture. And the eyes, inspired by R2-D2 and C-3PO, had eyelids to create expression.

Trashcan started with sketches but was primarily designed in 3D, helping to facilitate solving the "nose to the ground" challenge.

2003
Tetsuwan Atomu's birthday
In the story, Tetsuwan Atomu was "born" on 7 April 2003 at the Ministry of Science in Takadanobaba in Japan. In commemoration, colorful events are held in front of Takadanobaba Station.

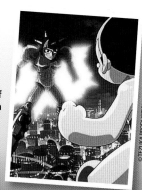
© TEZUKA PRODUCTIONS/SPE J

2004
Astro Boy in Robot Hall of Fame
Astro Boy is inducted into the Robot Hall of Fame, in the School of Computer Science at Carnegie Mellon University, the same year as C-3PO from Star Wars and Robby the Robot from Forbidden Planet.

2008
Imagi announces Astro Boy film
Imagi Studios, the same studio that produced Teenage Mutant Ninja Turtles, officially announces that Astro Boy the Movie will be released as a computer animated 3D feature film.

2009
Astro Boy the Movie
Imagi and Summit Entertainment release Astro Boy in Japan on October 9th and the US on October 23rd. When scientist Dr Tenmu's son is killed, he creates a robot replacement but then cannot accept it...

Artist Portfolio
ROSS TRAN

The American tells Gary Evans how he emerged from a "dark place" to become an in-demand artist and YouTube sensation, all before graduating college

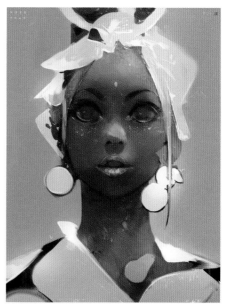

ASTRO MINT
"A piece from my Astro Series. It's a collection of portraits involving some kind of white garment and shapes as the influence."

BEACH
"This was one of the few pieces I did in my year off art to pursue acting. I just loved to paint and felt the need to express myself artistically."

Ross Tran steps out of his Californian apartment. The sun shines in the sky above and a car idles on the road below.

Holding a couple of large canvases, he climbs over a balcony, shimmies down a tree and speaks to camera: "Welcome to another episode of Ross Draws. It's my graduation episode!"

He runs to the waiting car. Animated sparks fly. He throws his artwork through the open window, jumps into the driver's seat and speeds away. The hand-written personalized number plate taped to the back of his Chevy reads: COLOR DODGE.

In just 20 seconds, we see why the 23-year-old artist's videos have earned nearly two million views on his YouTube channel: the quick cuts, the playful tone, the breathless,

almost hyperactive presenting style; whistle-stop tours of his art school, apartment and various locations around California; interviews with the smiley, unbelievably healthy-looking friends and teachers who populate those places... And, of course, the thing that underpins the channel's success, Ross's art – bright, stylized, painterly, with tutorials explaining how he produces it. What you'd never know by watching these videos is that the channel "came from a dark place."

Personality is key

Ross is a recent graduate of Pasadena's ArtCenter College of Design. He won his first concept artist job at the nearby West Studio when he was just 17. A couple of years later, he worked as lead character designer on his first feature film – creating Echo for the 2014 animated movie Earth to Echo. He now counts among his clients Disney, Samsung and Microsoft, and has since worked on the upcoming Halo Franchise and several more films.

How did he win so many big jobs at such a young age? "You have to personalize your portfolio so it represents what you really want to do," he says. "For instance, if you love character design and want to get hired for it, make your portfolio and online presence character-based. I've seen a lot of people put

too many types of work in their portfolio. It makes them look disposable. The last thing you want to be is a robot. Show the world who you are and what you want to do."

He says some people may be familiar with his earlier work, but most of this success has come through Ross Draws, the YouTube channel that he started at the end of 2011.

"I actually grew up really shy," he says, an image very different from the boisterous character he presents in his videos. "I had a lot of insecurities growing up. I think Ross Draws represents a side of myself that depicts transformation and self-growth. I

ARTIST PROFILE

ROSS TRAN
LOCATION: US
FAVORITE ARTISTS: My early artistic influences are more fine art and painterly: Craig Mullins, Leyendecker, Claire Wending, Jaime Jones, Sargent and Sergio Toppi.
SOFTWARE USED: Photoshop
WEB: www.rossdraws.com

KATARA
"This was a memorable piece because it was intensely challenging trying to paint water and waves. I had to really try to capture the physics, yet keep it stylized."

The last thing you want to be is a robot. Show the world who you are and what you want to do

NIDALEE
"This was from the third episode on my YouTube channel, drawing Nidalee from League. She's one of my favorite characters and I had to draw her!"

● NIMA

SPECTRE
"My work has recently taken a more stylized, graphic approach, while still pertaining to my painterly roots."

◄ **ROSS AND MILO**
"I always got tons of requests to draw my dog and found a perfect opportunity – to celebrate one year on YouTube."

consider myself an introvert, but one who's learning extroverted skills."

Even after earning a place at the prestigious ArtCenter College of Design, Ross says he felt something was missing in his life. He was passionate about art, but also loved making people laugh. So he took a year off and pursued an acting career.

Ross juggled art school and auditions. He took extra classes in improv and scene study. The nearest he got to a big break was an audition for a pilot on the Fox network. The small part called for a designer who freaks out a lot. "My perfect role!" Ross says. The producers of hit shows Psych and Scrubs were in the audition room and he made them laugh. They gave the part – which the script labeled "Asian Best Friend" – to a white person.

"I'm not sure the pilot even got picked up," he says. "But it was a great experience. I also auditioned for a lot of commercials."

Branching out on YouTube

A friend suggested he start a YouTube channel combining the two things: art and making people laugh. "I hesitated, thinking it wasn't really my thing. Prior to the channel, I felt like I had no purpose. I was waking up and feeling really unmotivated to do anything. Uninspired, unwilling, defeated.

"Acting helped me to commit. Because, in acting, you have to commit 110 percent or else no one will believe you, not even you. You can't be in your head. Going on those auditions and to classes helped me to commit to the moment and just do it, no thinking. It's

THE KEY STEP IN A JOURNEY

Like few other artists, Ross can pinpoint the exact moment he found his own artistic voice

"Journey is definitely one of my favorite and most memorable personal pieces," he says. "I'd been in school for about a year and was learning a lot, but hadn't really applied it. I didn't know who I was as an artist. In class, I felt I was creating a lot of cool stuff, which showed my artistic influences, but there was little of me in there."

Ross wanted to "bring something to life." He says Journey proves hard work really does pay off. All the best elements of Ross's work came together: it's colorful and stylized but painterly; the composition is strong and the characters are suggestive of a much larger narrative than we're seeing.

After completing Journey, Ross started understanding the kind of workflow that suited him. "I began to really love painting," he says. "I started to absorb information faster. This piece hung in my school's gallery and was a staple of my portfolio. It was definitely a breakthrough moment."

JOURNEY
"I really wanted to express a sense of movement and vision with this one."

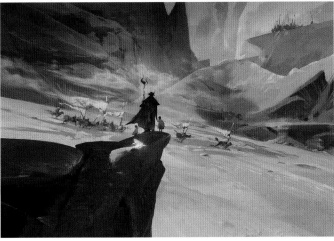

RED
"This was another one that sat in my folder for about two years. I never knew how to finish it, but one day I opened it up and let the story breathe."

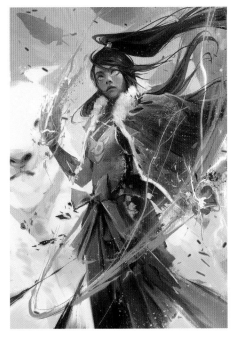

KORRA
"This piece is quite special to me. People often mention that this was one of the first episodes/pieces they saw when they discovered me."

POWERPUFF GIRLS ▶
"I grew up watching The PowerPuff Girls and wanted to do my take on it. I was bringing my love of graphics in the piece."

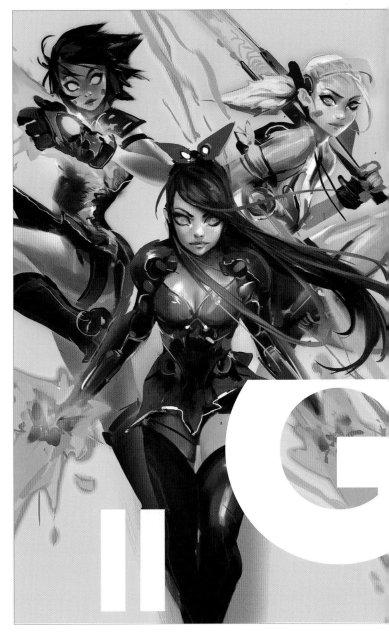

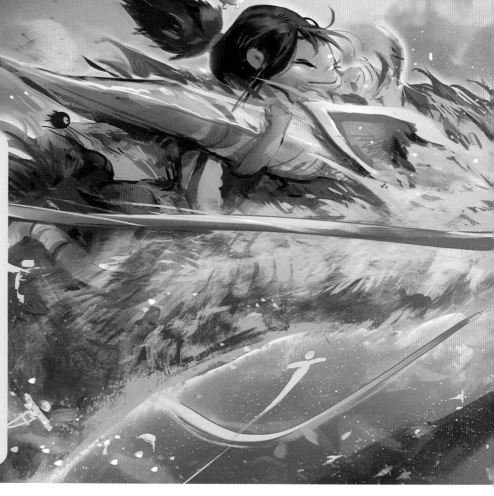

MASTER OF COLOR DODGE

Ross on the Photoshop tool that his fans know has become his signature technique

"I really didn't even know it was going to be a thing of mine. It's part of my process in almost every painting, so my first YouTube video included that step.

"I got so excited in the video that everyone started to say it! Color Dodge makes my painting colorful, vibrant and full of light. You can see here: it can add a lot of story and bring your piece to life."

The blending mode adds a depth and glow to colors. Ross used to feel such techniques were cheating. Now he realizes artists must embrace the tools that help them best tell a story. "It doesn't matter. You can learn from anything, any method, anywhere. Have an open mind. I wish someone had told me that when I was starting out."

a practice I've also taken into my art. If you have an idea, don't be afraid to voice it."

When Ross reinvented himself as Ross Draws, it shook up his personal life and kickstarted his career. But the success of the YouTube channel brought new problems. "My schedule is different every week, every day," he says. "Sometimes I feel I overload myself. I'm definitely what they call a night owl. I go to sleep anywhere from 2 to 5am. As my channel grows, so do my opportunities – conventions, signings, gigs – and it's been harder to have a set schedule. It's still currently a learning curve. But most of my week consists of editing my videos and painting."

Growing up, Ross was into TV shows like Pokemon, Sailor Moon and Power Rangers – you can see those influences in his art and on his channel. He has a few key rules when making videos. Our attention span is getting shorter and shorter, he says, so he keeps footage under the six-minute mark. It's also important to be yourself, connect with your

audience and collaborate with other people. He's made videos with artists he looks up to, like Dan LuVisi and Anthony Jones, but also collaborations with non-artists, such as Jimmy Wong and Yoshi Sudarso, who plays the Blue Ranger on the new Power Rangers show.

The YouTube channel brought Ross new confidence, which was mirrored in his art. When he started at ArtCenter College of Design, he knew he was a capable painter but felt his work was too heavily influenced by his favorite artists. Then he painted a piece called Journey (see page 43)– a landmark in which he found his own voice and techniques.

Ross works with Premiere and After Effects for his videos, Photoshop and Lightroom for painting. Using all Adobe software helps him easily switch between apps. One website recently labeled him the "Master of Color Dodge". The blend mode creates depth and makes colors really pop off the screen, a glowing effect that's present in much of Ross's work.

It's not cheating

Ross hadn't always used such techniques. "At a young age, I thought that using certain methods as cheating, only to realize now that it doesn't matter. You can learn from anything, any method, anywhere. Have an open mind and you can absorb information easier and faster."

After graduating college, Ross left the apartment that features in many of his YouTube videos. He now rents a house with friends, a place just outside Los Angeles. "We call it The Grind House," he says. The Grind House? "It's where we're going to grind on our stuff for a year and decide what to do from there. There's not much of an art scene in my area, but I love the motivational energy that the house has."

"Motivational energy" is a perfect term. It's in everything Ross says and does. You can still see his influences in his work. There's a bit of Jaime Jones in there, some Craig Mullins and Claire Wending. But despite his youth, he has found a style, voice and motivational energy of his own – and, perhaps most importantly, a platform on which to share it. That's the one piece of advice he's

❝ I thought using certain methods was cheating. But you can learn from anything, any method, anywhere ❞

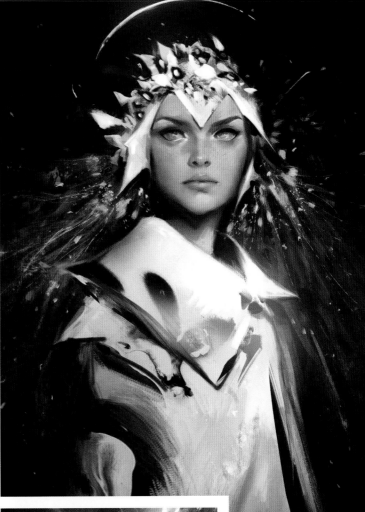

ASTRO FIRE
"This has been sitting in my WIP folder for about three years. A lot of my pieces sit there until I can see the piece turn into something unique to me."

keen to get across: do it your own way, on your own terms.

"My videos are funded by my amazing supporters on Patreon. I'm blessed to have fans who love what I do and who want the exclusive content that comes with each episode. Patreon is definitely a career option for artists." Ross's endorsement of Patreon comes with a caveat, however: only launch when you're ready. "I held off on making my page until I knew I had quality content for the people who supported me. "If you do what you love, numbers and finance shouldn't matter," Ross adds. "I have friends who absolutely love their studio jobs and want to be surrounded by people. I also had friends who quit those jobs, made a Patreon and earned less, but loved what they do.

"I think it's about finding your own instrument and how to operate at your fullest potential. In today's industry – and society – we too often compare ourselves to others, which fuels our inner self-critic. We're all on our own journey at our own pace. We all have different inspirations, a different drive that propels us forward." ■

REAPER
"This piece was commissioned for the deviantART+Blizzard Campaign '21 Days of Overwatch'. It's probably my best seller at my first convention, Anime Expo."

JINX
"There's always a whimsical element to my work, either in the colors or the composition."

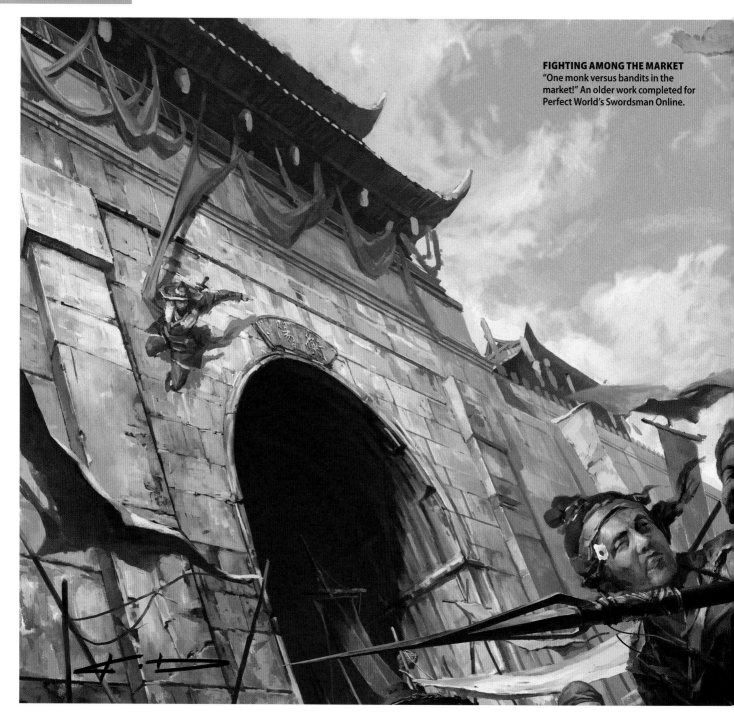

FIGHTING AMONG THE MARKET
"One monk versus bandits in the market!" An older work completed for Perfect World's Swordsman Online.

Artist Portfolio

KD STANTON

One of the new wave of Chinese artists surfacing in the West, KD Stanton arrives with a prodigious talent seemingly fully formed

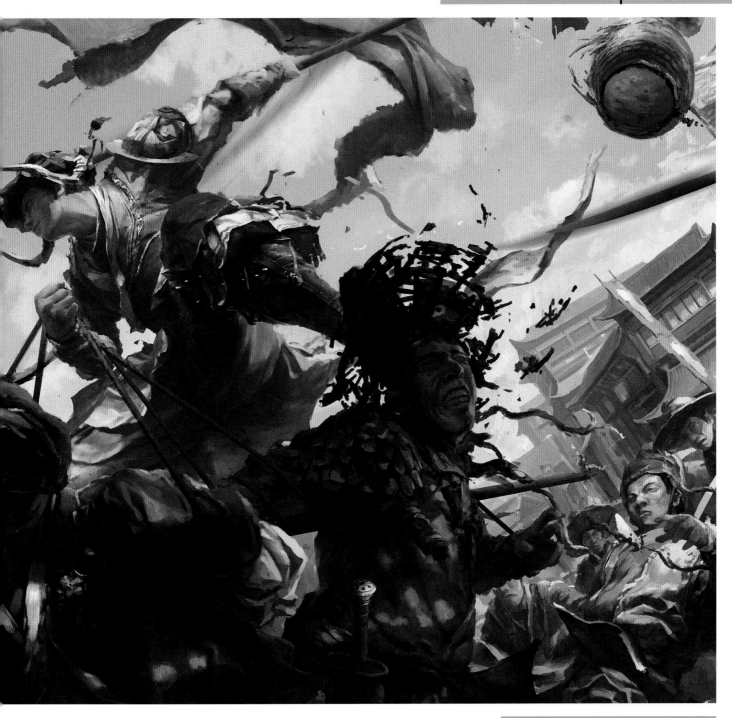

When I started out in the industry, being good at brainstorming ideas, communicating and being able to learn were my 'big breaks'," says rising artist KD Stanton. "As an industry novice, the things I lacked most were work experience, confidence and the mental capacity to deal with difficulties. Being good at communication and self-learning helped me avoid taking a lot of wrong turns. Being good at coming up with ideas helped me get better at solving problems in a short space of time, and also improved my confidence, which gave me the determination to overcome challenges."

This modest appraisal belies KD's astonishing body of work, which is now beginning to attract Western audiences and clients outside of his native China. (And if you thought KD Stanton doesn't sound very Chinese, you'd be right – his real name is Feng Weirui.) KD's images are wonderfully kinetic, matching up dynamic composition and incredible lighting with pure mastery of technique. His action shots in particular often look like frames from a film.

It's a technique KD has deliberately cultivated. "I'll create one or more simple compositions in advance, based on the different requirements and expressing what I want in terms of content," he explains in

ARTIST
PROFILE

KD STANTON (FENG WEIRUI)
LOCATION: Nanjing, China
FAVORITE ARTISTS: Ilya Yefimovich Repin, Anders Zorn, Adrian Smith, Craig Mullins
SOFTWARE USED: Photoshop
WEB: www.artstation.com/artist/kd428

Mandarin. "But this method doesn't always work, because sometimes a certain requirement will call for an unexpected camera position, which tests my skills." This, of course, is more likely to happen with a client brief that specifies a particular

WHIPLASH
Another concept scene for Swordsman
Online, created in 2013.

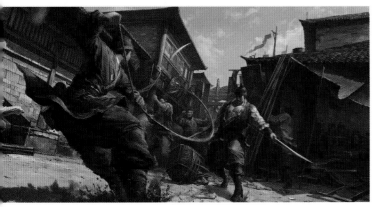

ORCWARD BUSINESS
Traditional orcs don't come much nastier than in KD's own imagining of them.

STREET FIGHTER
No story behind this one – come up with your own ideas about what's led to the confrontation...

RISE OF THE HORDE SARNUK BLOODSOUL

KD Stanton on his favorite piece of art and why it was a game changer for the artist

Which of KD's pieces does he feel most proud of? "That would be Rise of the Horde Sarnuk Bloodsoul," he says. This was a personal piece depicting orcs on the rampage. It has its own little backstory, which you can read on KD's website.

"You could say that I started to progress a lot from this picture onwards," he says. "It was quite a big breakthrough for me. This was the piece where I realized the importance of the overall composition.

"With my work before, there was always something missing in the overall feel and it tended to lack adequate dynamics and atmosphere. In this piece, I think I finally captured just the right balance between dynamics and details, for the first time. And that has gone on to be a big feature of my current style.

"I'll never tire of making more art in this style, because I always find something interesting in the process."

> **" I think video gaming has been my biggest motivation in what I have achieved so far as a self-taught artist "**

composition. "That's why the basics are more and more important [to me]," he adds. "Knowing how to unite control, expression and the painting is the only way to succeed – because regardless of whether you choose the camera position by yourself or it's set for you, in the end you still need to draw the painting."

Those drawings generally begin on the computer rather than as paper sketches, though KD says he doesn't really have a set routine when working on a piece, instead adapting his process depending on the project. "Most of the time," he explains, "for this type of drawing I start with an outline composition, and after that has been finalized, I do a basic coloring of the design,

making adjustments as required, and then I start to work in more detail. It's a progressive process until the piece is finished. If there's enough time, I'll do some pencil drafts before developing the composition, which helps me get into the artistic mood better."

All in the games
It's hard to believe, but KD has never taken a professional art course – he graduated in computer science and technology from Sichuan University. But like many younger artists, he was obsessive about video game art in his youth and played many games, which have influenced his visual style ever since. Indeed, he says, "I think this has been my biggest motivation in what I have achieved so

far as a self-taught artist." Now, as a freelance artist, he works with numerous local clients – on projects that rarely surface in the West – as well as with international companies such as Blizzard, Games Workshop and Riot Games. "I live in Nanjing at the moment," he says. "I've also lived in three other cities: Chengdu, Beijing and Guangzhou. Because of work, I don't have many chances to travel. The few places I've visited have influenced my art, of course. For example, the Gobi desert, Lugu Lake in Yunnan Province and Jiuzhaigou."

China, of course, has a massively rich and varied history when it comes to visual arts, and KD isn't averse to drawing on the country's artistic heritage now and then –

LEAGUE OF LEGENDS 2V2

KD explains the thinking behind his kinetic
concept art for the mega-popular MOBA

This concept art piece for Riot Games' League of Legends online
battler is one of KD's favorites. It was designed to demonstrate the
teamwork behind the game's 2v2 mode.

"I picked Draven and Darius for team A, and Katarina and
Hecarim for team B," KD explains of the characters featured in the
image. "I then did some sketches for the concept." He says the
biggest challenge in this image was keeping the color saturation
high and having strong, contrasting color tones.

He also added Riot Games' style, he says, using plenty of
lighting effects to bring out the drama. "Along with the contrast of
warm and cold colors, each character in my painting has a sharp
contrast and reflects each others' personality. It also made a cool
composition for the story. It's all about making my storytelling
more interesting."

1 Initial composition
I start by drafting a fairly simple
composition. Darius is attacking
Katarina; Katarina, however, is cleverly
dodging the attack, while Hecarim
confronts Draven. Darius is a strong
character, a hero, so I have him waving
his axe in order to make him look more
powerful. It's a night-time scene, so I
have to think about silhouettes.

2 The story emerges
I brighten the picture a little, then
increase the saturation. Then I adjust the
dynamism of the characters again,
experimenting with special effects. A
plot emerges: Darius didn't hit Katarina
but the brazier instead. Katarina dodged
the attack and sneaked behind Draven.
This makes it feel more dynamic.

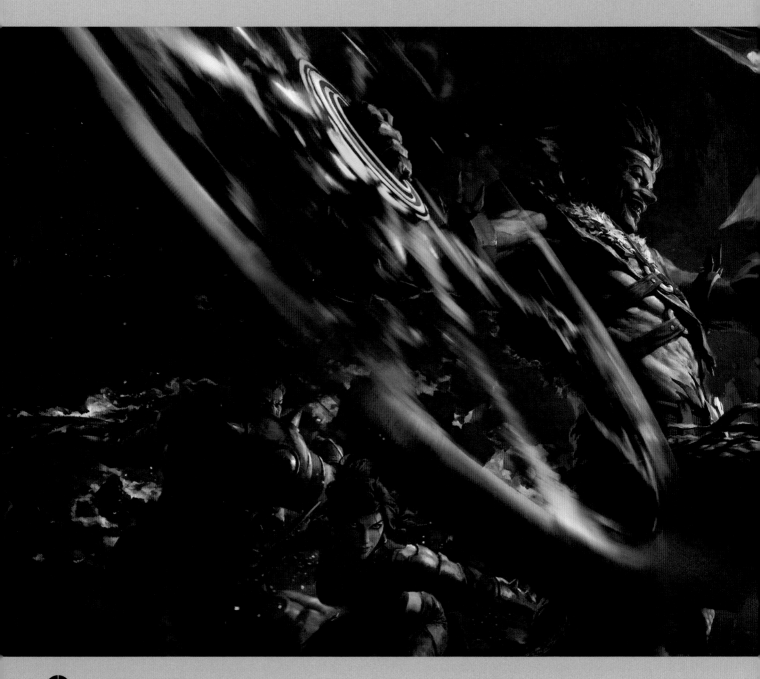

All images © Riot Games

3 Getting into detail

Draven is crafty, he's a guilty hero, so I give him a exaggerated pose as he waves his axe, as well as a sinister smile to help his character resonate with fans and players. With Hecarim, I let him have his shadows rush towards Draven. I add some details to the background at this stage too, and on the characters.

4 Background

I join the fire up in the background and expand the scope of its impact. Again, I slightly adjust the dynamic levels and sense of volume. The distinction between primary and secondary isn't an obvious adjustment, so I dim my screen and adjust the brightness, to make the composition feel a bit more complete.

5 More adjustments

Now the background feels a bit too close, so I join the distance between the perspective, characters and background. I adjust the figures again to highlight details. To help make the screen feel like it's moving, I add some flying stones.

6 Final tweaks

For better perspective, I adjust some character sizes to form a clear hierarchy and add dynamism. And it's done!

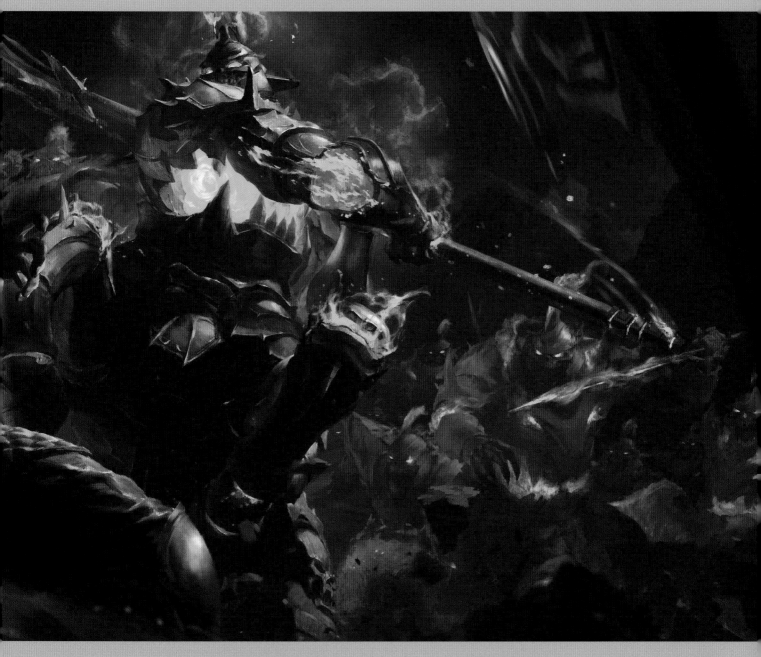

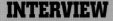

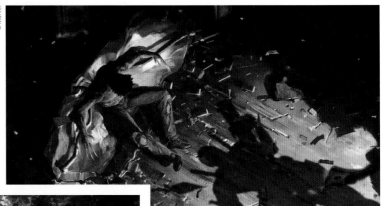

WOLVERINE VS DEADPOOL CORPS

KD was invited by CB Cebulski to paint a Marvel scene. Here's how he went about it…

"Because you don't have total creative freedom when painting established comic characters, the difficulty is relatively large. I pick one I know a little better, Wolverine.

"I depict Wolverine riding a motorcycle in the wind, with Deadpool Corps as the provocateurs. I add a bridge above them, so the more dramatic lighting will be seen. I work hard to create realistic lighting.

"I make it more symmetrical on both sides, to break the background feeling. I adjust the sign many times: I like to use elements of the scene to help manufacture the story. I adjust the overall light and add more detail. After adding contrast, subtle color changes make the painting look richer."

MARVELLOUS
KD feels justifiably proud of having done concept work for Marvel.

EASY MONEY
Oops, looks like you got my invitation, Wolverine…

REVENGE FOR SYNDRA
"Fan art for League of Legends, featuring Syndra, Maokai, Thresh, Lucian and Rengar."

though you definitely wouldn't stereotype him as a "Chinese" artist. "What has influenced me the most is the aspects of tolerance and synthesis of Chinese culture, which is something that I've thought about from time to time and gradually started to explore," he says. "Regardless of what aspect of the culture [you look at], being able to examine and understand the essence of it and use it – that's my main inspiration."

Currently, most of KD's time is taken up with preproduction for two films in the Legend of Ravaging Dynasties (LORD) series, directed by Guo Jingming and scheduled for release in the middle of 2016 – although again, these are unlikely to be shown outside of China. "My main work is handling all the different conceptual designs and drawing up

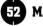

KING OF LYCAN
More private freelance work and a great take
on the well-worn werewolf theme from KD.

◀ **THE PRINCE OF ARC**
Older freelance work for a private client,
depicting Blake Archer, aka the Prince.

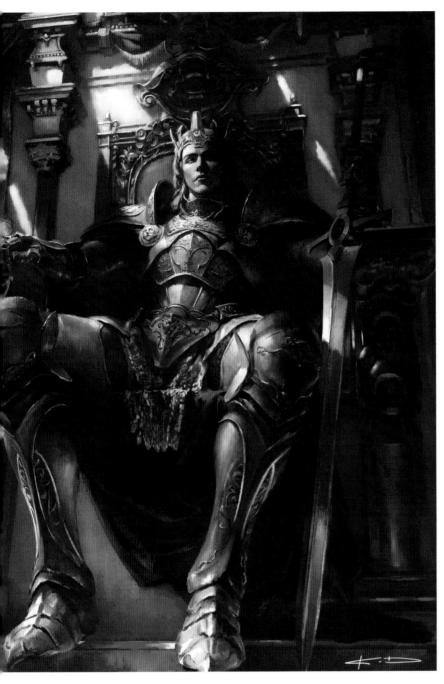

> **❝ I love sculpture. I also have a
> large collection of film and
> television merchandise ❞**

the artwork for the atmospheric effects, as well as overseeing the main scene designs," says KD. He's also been hired by Chinese game company Perfect World, which develops numerous online games such as the incredibly popular DOTA 2, as well as lesser-known titles such as Empire of the Immortals (a long-running MMORPG) and Hot Dance Party, another online-only title where the clue is in the name.

"There, I'm responsible for the main poster designs for numerous art projects, and leading the team responsible for the preproduction concept art for CG trailers," he says.

Wherever possible, KD prefers to work at his clients' studios while on a project: "I really like working in the studio because I like to interact with colleagues and find it interesting cooperating with people," he says. "I find it helps us all to improve what we do."

Time for sculpture

Clay modeling is another area which interests him. His website portfolio, for instance, features a brilliant rendering of Sir Ian McKellen as Magneto in the X-Men films, as well as Bill Nighy in Underworld. Their accuracy is incredible.

"I love sculpture," he beams. "I also have a large collection of merchandise from films and television programs. I'd love to make some things completely in my own style, but I lack the time and I'm limited by materials, so I only have some semi-finished pieces at the moment." But it's more than a hobby: creating a 3D representation of a character can help

with figuring out lighting and facial structure. "Sometimes you can greatly improve the structure of the bodies in a painting by referencing physical objects," he says.

"It can give you more ideas, too. For example, you're portraying a person's face, and you think the bottom part of the facial structure will look 'tougher' with side lighting – but then you try it backlit with a real model, and you discover something you didn't think of before."

The year 2016 looks set to be KD's biggest yet, with more commissions and projects on the go and, with luck, a move into other areas of development.

"There are a lot of opportunities presenting themselves to me," he says excitedly. "I'd love to be able to work with some of the masters, and I also hope I can inspire more people," he adds.

"In terms of films and television programs, I'd like to increase my exposure to a variety of different conceptual designs and be able to discuss my ideas with directors." Frankly, we're as excited about his new projects as he is. ∎

Sketchbook

Patxi Peláez

Comic characters are trying to leap from the pages of this Basque Country artist's sketchbook

ARTIST PROFILE

Patxi Peláez
LOCATION: Spain

Patxi lives in the Basque Country, northern Spain, where he's worked in the animation industry for more than 20 years, as an art director, character designer and in visual development for feature films and television. He's also an illustrator of children's books for various publishers in Spain.
patxipelaez.blogspot.com

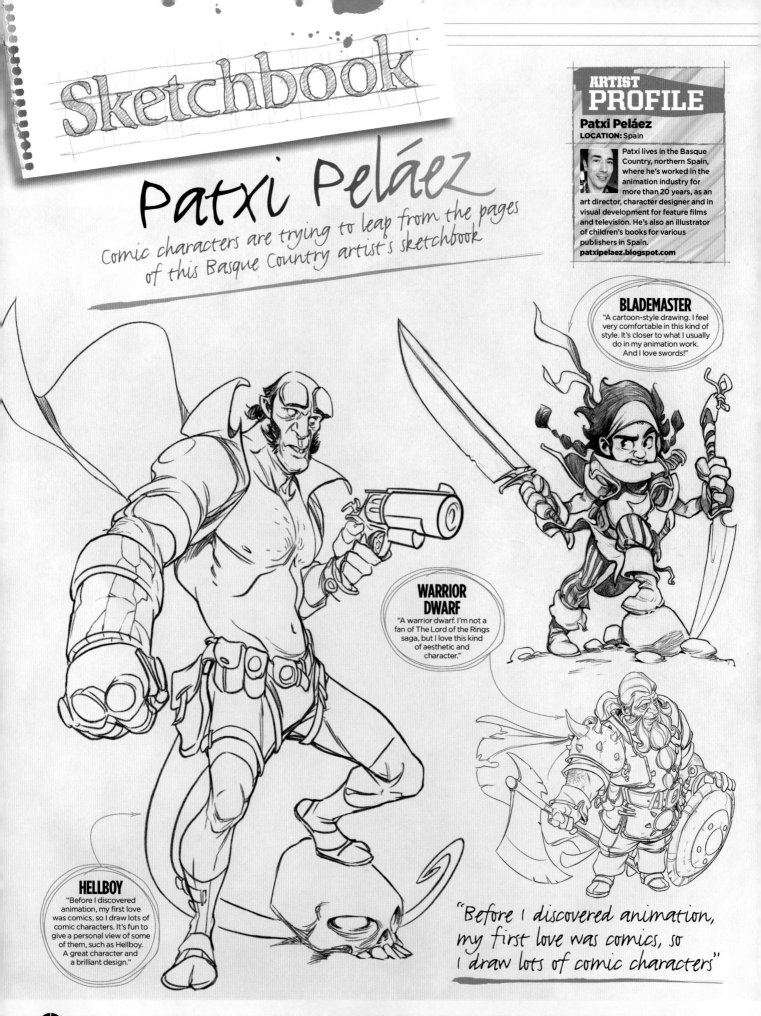

BLADEMASTER
"A cartoon-style drawing. I feel very comfortable in this kind of style. It's closer to what I usually do in my animation work. And I love swords!"

WARRIOR DWARF
"A warrior dwarf. I'm not a fan of The Lord of the Rings saga, but I love this kind of aesthetic and character."

HELLBOY
"Before I discovered animation, my first love was comics, so I draw lots of comic characters. It's fun to give a personal view of some of them, such as Hellboy. A great character and a brilliant design."

"Before I discovered animation, my first love was comics, so I draw lots of comic characters"

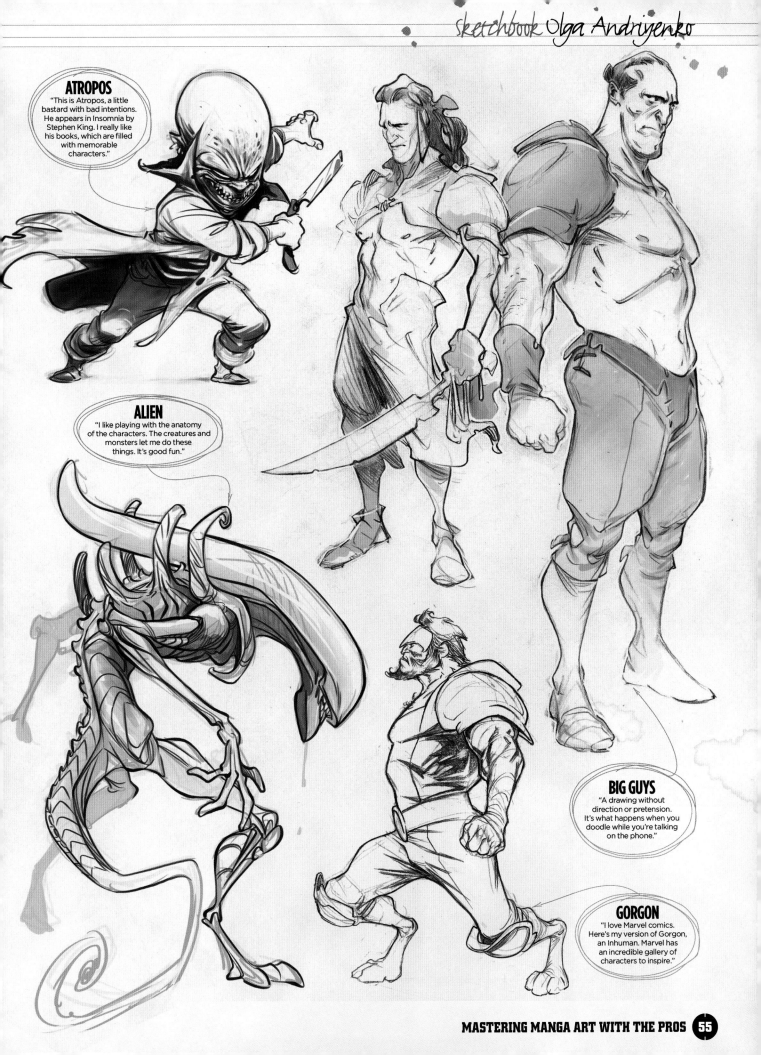

ATROPOS

"This is Atropos, a little bastard with bad intentions. He appears in Insomnia by Stephen King. I really like his books, which are filled with memorable characters."

ALIEN

"I like playing with the anatomy of the characters. The creatures and monsters let me do these things. It's good fun."

BIG GUYS

"A drawing without direction or pretension. It's what happens when you doodle while you're talking on the phone."

GORGON

"I love Marvel comics. Here's my version of Gorgon, an Inhuman. Marvel has an incredible gallery of characters to inspire."

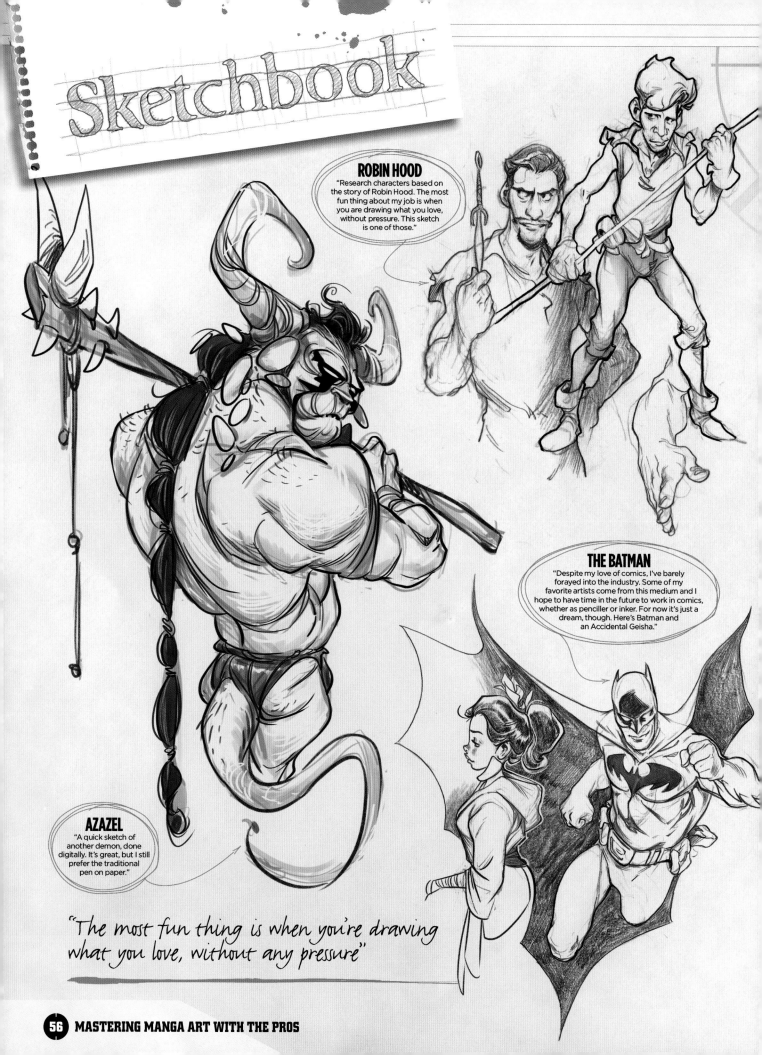

Sketchbook

ROBIN HOOD
"Research characters based on the story of Robin Hood. The most fun thing about my job is when you are drawing what you love, without pressure. This sketch is one of those."

THE BATMAN
"Despite my love of comics, I've barely forayed into the industry. Some of my favorite artists come from this medium and I hope to have time in the future to work in comics, whether as penciller or inker. For now it's just a dream, though. Here's Batman and an Accidental Geisha."

AZAZEL
"A quick sketch of another demon, done digitally. It's great, but I still prefer the traditional pen on paper."

"The most fun thing is when you're drawing what you love, without any pressure"

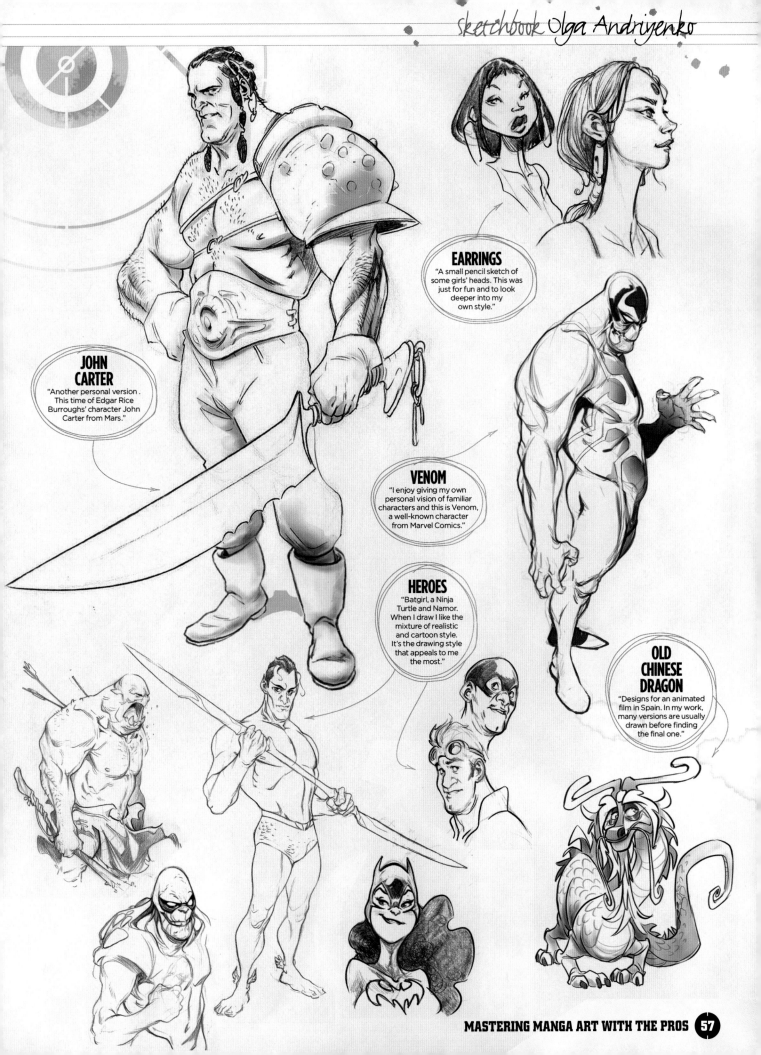

EARRINGS
"A small pencil sketch of some girls' heads. This was just for fun and to look deeper into my own style."

JOHN CARTER
"Another personal version. This time of Edgar Rice Burroughs' character John Carter from Mars."

VENOM
"I enjoy giving my own personal vision of familiar characters and this is Venom, a well-known character from Marvel Comics."

HEROES
"Batgirl, a Ninja Turtle and Namor. When I draw I like the mixture of realistic and cartoon style. It's the drawing style that appeals to me the most."

OLD CHINESE DRAGON
"Designs for an animated film in Spain. In my work, many versions are usually drawn before finding the final one."

LOCATION: Los Angeles, US
PROJECT: League of Legends
OTHER PROJECTS:
Blitzcrank's Poro Roundup
(mini game)
WEB: www.riotgames.com

◀ STUDIO PROFILE ◀

RIOT GAMES

Manga Artist heads to California to see
the huge new home of **Riot Games**,
the team behind League of Legends

Standing guard near reception are life-sized statues of Annie and Tibbers, the Dark Child and the Shadow Bear. On the walls around them, a rogues' gallery of official and player-created art, characters with names like Amumu the Sad Mummy, Warwick the Blood Hunter and Gangplank the Saltwater Scourge. These champions, and the 67-odd million monthly gamers who play them, helped League of Legends (LoL) become one of the biggest, and best loved, video games of all time.

We are in west Los Angeles, at the offices of the team behind LoL. Except Riot Games doesn't call this place an office or a studio, or

even its headquarters. This is a campus. The name fits – not just because it's sprawling, but because an important part of the work that goes on here has to do with learning, with striving.

In case you've been in a cave for the last several years, League of Legends is a multiplayer online battle arena game. A really big one. Released in October 2009, it remains Riot Games' only title. A couple of gamers, Brandon Beck and Marc Merrill, founded the company in 2006, and it's since grown into not only one of the most bankable game developers around, but also one of Fortune's 100 best companies to work for – debuting at number 13 in 2015.

The Grand tour

Strolling around the campus, it's easy to see why. Walkways lead through the site's sprawling quad, among drought-friendly plants, past a giant chess set, with fairy lights leading the way overhead. There's a basketball court between the canteen and café. Inside one of its wings, an old-school arcade room and a modern PC bang. There is, in fact, almost 300,000 square feet of space, housing well over 1,000 employees. When Riot moved here a year ago, The LA Times reported it as the "biggest new office lease in southern California in five years."

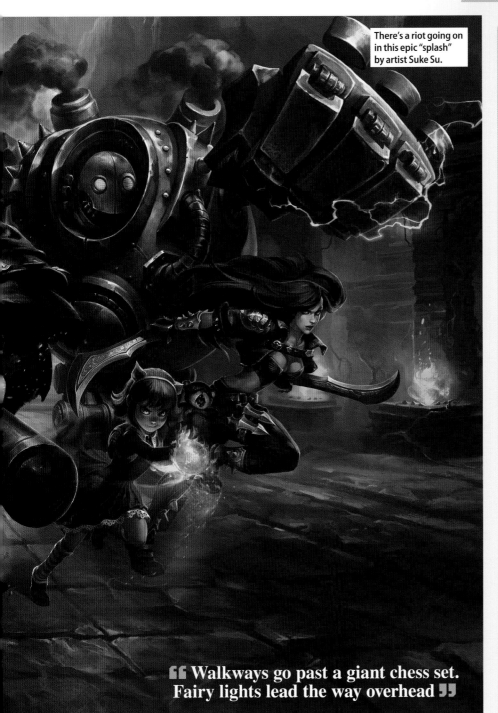

There's a riot going on in this epic "splash" by artist Suke Su.

> ❝ **Walkways go past a giant chess set. Fairy lights lead the way overhead** ❞

JASON CHAN
When LoL needed a new look, Riot turned to the former Massive Black artist

What do you like about Riot?
Riot has done a very good job of providing a comfortable, uplifting environment, where people want to be. Everyone is professional, everyone is trusted to do their work. The crazy thing about Riot is that we allow the entire company to see most things. It doesn't matter if you are in the art team or not, you have a voice. If you're getting a large percentage of the company that's not involved in the asset, but feeling strongly about it in a negative way, then you know exponentially that same feeling will exist elsewhere outside of the company.

What does Riot do differently?
It places quality above speed and budget. There's always an opportunity to talk about pushing something back and spending more time on it, turning it into something special. This was foreign to me when I started here. I was very obsessed with staying on schedule and I would get very nervous when a deadline was approaching and we hadn't settled on a solution. I had to get used to the idea that it's not about getting it out as fast as possible. It's about making sure something is going to be valuable as art.

Why does the company look for in an employee?
You're spending more time with your team than your family, probably. So you want to surround yourself with people you want to be around. The company actively does that. Sure, you're good at your job, but are you someone everyone wants to be around? It sounds like a high school popularity contest, but it's just like a way of keeping everyone happy. If you're around people who are inspiring, there's no limit.

How do you make an impression in such a big organization?
By being a conduit for everyone's ideas and being able to take those ideas and represent them in a cool way. You have to be very open to critique and to know that sometimes your idea isn't the same as other people's. That sometimes means cutting your idea out and running with theirs, even when you're very passionate about your own. That can be a tough switch and I've seen people struggle with it. That's a big thing at Riot. You're not doing artwork for yourself anymore. Sometimes it's nice to own a piece of artwork, but sometimes it's just nice to know you've contributed to something bigger. It's not your show.

Before joining Riot Games, Jason studied at San Francisco's Academy of Art, freelanced for Magic: The Gathering and worked at Massive Black.

www.jasonchanart.com

Adam Murguia is Studio Art Director at Riot. On his first day, he called his new team into a meeting: "I said, 'Look, there's a lot about the game's look that's great. It's original, it's super, super broad, but it's really inconsistent when it comes to quality and consistency across the board and that's one of the things I think we need to fix'." He braced himself for a backlash. But the team, to his surprise, agreed with him.

In the four years since, Adam has grown the art department from 20 staff to more than 200, a kind of dream team of digital artists. The campus on which they work is a flexible space, one designed to adapt to Riot Games' collaborative approach.

"Our focus turned to the product, to holistic product quality," Adam says. "So all of these desks, they're all on wheels, they're all plugged into the hubs, and literally the configuration is different week to week. Teams self-organize. One of the things we hire for is adaptability."

Everything on campus is carefully thought-out: champion-themed conference rooms sit in the centre of workspace areas, so teams aren't interrupted by Rioters rushing in and out of meetings. The Korean-style PC bang – the kind of large gaming room where many fans play League of Legends – is where work

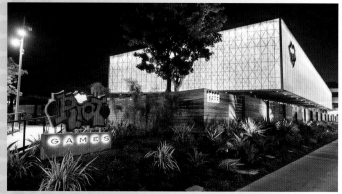

With its organic culture of creativity, Riot is a unique games studio.

The Bilgewater Brew enables Rioters to get caffeinated for the day.

> **We just say, 'We need an awesome champion. Go do what you need to do to make an awesome champion'**

and play overlap. Nearby machines vend endless snacks. There are bars and cafés, and almost 100 breakout rooms.

"We're not the company to say, 'Hey, concept artists, do 10 concepts by Tuesday'," Adam says. "We just say, 'We need an awesome champion. Go do what you need to do to make an awesome champion'."

In League of Legends, you play an unseen summoner. You control a champion who has unique abilities and battle against a team of players or computer-controlled champions. The Riot team, or Rioters, can take around eight months to create and complete a champion. As many as 100 people from various disciplines are involved in that process. Adam says there are over 120 playable champions and each can have multiple skins. Skins range from simple costumes to full thematic overhauls. They don't boost the character's stats, just change their appearance. Paid-for cosmetics are where free-to-play League of Legends generates much of its money.

Anyone for eSports?

League also has a huge competitive element to it. Regional competitions culminate in the annual World Championship, which in 2015 offered over $2m in prize money and attracted almost 40m online viewers.

"Our audience is hardcore gamers," Adam says. "We hire hardcore gamers, so we're also very critical of the products we're creating. We're critics, man, we really are. And when something's resonating internally, it's a good sign. We're very collaborative, we're very competitive, we're achievement driven, we're a team. We're not a family, you know. The distinction being that you can't fire your grandma. We're very plain spoken. Somebody's not carrying their weight? They'll know about it."

POPPY GETS A REVAMP

Josh Smith works up a striking illustration based on a Jason Chan comic original (see page 71)

What started as a promotional comic from the stylus of Jason Chan, for the new look of a champion, ended in this beautiful and dynamic splash illustration of Poppy, Keeper of the Hammer. Josh Smith takes us on a step-by-step guide to how he created this lasting image.

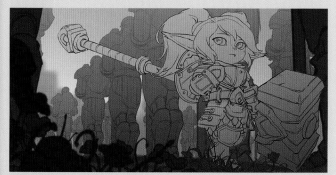

1 Clean and confident
I originally drew this for the cover of Poppy's digital comic, but everyone was so smitten by it that we decided to make it her splash as well. In this step I have my composition and story locked in. I've found that a clean and confident drawing at this stage will make the rest of the process easier and more reliable.

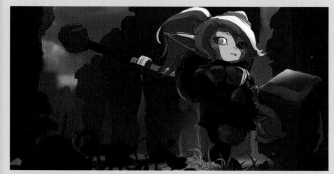

2 Rough color and lighting
With the help of masks for the major pieces, I do a rough color and lighting pass. My focus is on finding a mood that suits the story and champion. I'm looking for colors and setting up a lighting situation that makes me feel something, while also complementing Poppy's unique elements. This is the vision.

Fan-favorite comics and cover artist Alvin Lee was recruited by Riot's Splash Team just over a year ago: "Splash is basically just a name for an illustration team, which went from working almost as a standalone team to following the rest of the company into being more integrated. If I jump into working with another person, hopefully both of us will level up."

Around the campus, you hear terms like "level up" and "force multiplication" used a lot. Evan Monterro, an illustrator on the Champ Team, is one of Riot's newest employees. He explains what these terms mean: "I was sort of a generalist. I had a good amount of knowledge about a wide range of things. They want someone here that is a 10 in the thing

The art department transformed, and grew, four years ago when Adam came on board.

3 An ambient occlusion pass

Next is an ambient occlusion pass. A term generally reserved for 3D renders, this refers to nooks and crannies that light can't reach. By putting dark shadows with steep drop-off in areas where two objects meet or overlap, I get an illusion of volume.

4 Block in cleaner light and color

With my occlusion pass on a Multiply layer above everything, I create masks to separate major materials. I then block in a cleaner version of the light and color from step 2. I mask out and treat the background and soldiers in a similar way.

5 Refining details

I start to see the fruits of my labors. Masks keep me sane while I render materials, zooming out often. Once it looks clear and believable, I suck it up and keep painting. Our splash style is to feel like a photograph from a fantasy world, so I refine details further. Lastly, post-processing: light bloom, depth of field and color adjustments.

we're hiring for, and a 3 in everything else. Not 5s across the board."

Once they have the job, Rioters bump those 3s up to 10s by collaborating, which is how they level up and force multiply. There are also on-site sketch groups, life-drawing classes and craft classes taught by Riot artists.

So how do you get a job at Riot Games? "Skill gets you in the door," says principal artist Moby Francke, "but more important is that you're a cultural fit." Moby's own remit is broad. "I work with everybody. I'm making characters sometimes, I'm doing paint-overs of somebody else's work, marketing, art direction for an event. Most things take six or seven months. This is a dream job for a lot of people. They let you take chances. They let you fail catastrophically, as long as you learn something from it. You're not just pigeon-holed. You're not a widget. We're extremely anti-widget at this company."

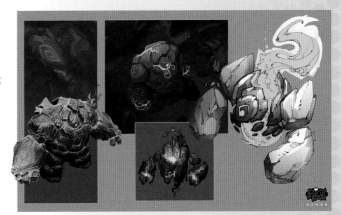

Some concept art from the Summoner's Rift map. It's the most viewed game map in LoL – and that's saying something!

SION'S LEVEL UP

Tasked with producing 3D models for one of the original LoL characters, Sion, Josh Singh helped update the champ for today

1 Baby (monster) steps

The art quality in League of Legends had far surpassed Sion's humble beginnings. He was a prime candidate for our Champion Update Team. We identified what makes Sion appealing and what wasn't hitting the mark. We identified the fantasy we were trying to deliver on. In Sion's case it was an Ancient Unstoppable warrior, who'd been brought back to battle through fell magic.

2 Background's everything

After we found an idea and a few images we liked, we began to refine and add story to the design. We began to ask questions like, "What did Sion look like before he died?" We also asked things like, "Should Sion have any relationship or connections to champions who are currently in League?" We also began callouts of his weapon and character headshots, figuring out how undead we wanted to go.

3 Seeing in 3D

After we found a design we liked, I modeled Sion in ZBrush. We used the sculpt as a reference for the splash team as well as a source for the ambient occlusion map to speed up the texturing process. One of the key jobs of the splash is how do we want people to feel when playing this character? In Sion's case I think the splash team nailed it. In the splash he's destroying his enemies, and seeing them driven before him. Perfect Sion!

This splash of Miss Fortune by Jason accompanied a story event, aimed to enrich the existing character for Rioters and fans.

Never clock in again

"They don't hire guys who come in for a paycheck," concept artist Chris Campbell says,

"they look for the people who are passionate. My team's goal is to make a new character that's going to change the game. It's gonna fundamentally blow everyone's minds and be the kind of experience that gets people excited to play. If it doesn't reach a level of excitement with us, we just don't put the character out." Chris's job on the Champ Promo Team, he explains, is to develop the nuances of a champion – who they are and what motivates them. "It's never some solo project. It's open, a communal gathering of thoughts and ideas."

Senior concept artist Trevor Claxton says working at Riot is like working on an aeroplane that's being built in mid-air. And that's not to everyone's taste. "I've seen people come on-site and work like that for a while and just not be happy. They need peace and space to create the best work they can possibly create." It seems that working the Riot way may not be right for everyone, and could even upset its specific culture."

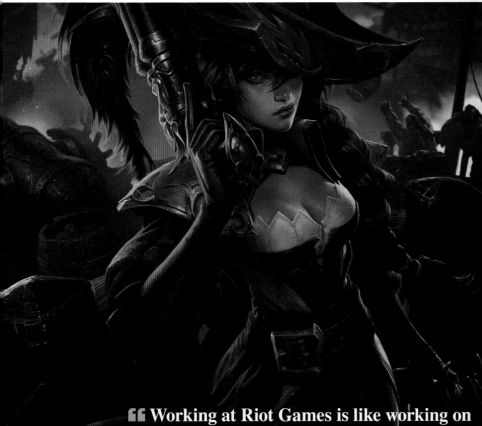

> **Working at Riot Games is like working on an airplane that's being built in mid-air**

 League of Legends is a game of great scope, built on meticulous attention to detail. The Riot Games campus is exactly the same. A lot of care is taken to create what appears to be a carefree working environment. And the results speak for themselves. "We are always trying to push, push, push," says skins illustrator Chengwei Pan.

"In other companies you might get a week or two to produce an illustration," he continues. "When other artists hear that they're like, 'What? It takes you four weeks to do one illustration?' But we're

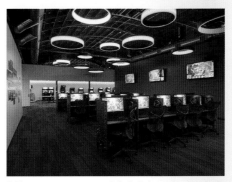

PC bangs are a common sight in Asia, and so Riot built its own in-house to keep Rioters connected with their gamer audience.

not wasting time. We have more iterations, more narrative talk and a lot more feedback than other illustrators get. That's why the quality of the illustrations keeps growing. Riot has a fantastic culture." ■

A detail from Jason Chan's Poppy comic, a release to give backstory to the revamped champ.

ALEX FLORES

The chance to work at Riot was a dream come true for the senior concept artist

With such a demanding job, how do you find time for you own art?
I find it hard to work on personal stuff these days because it's also the stuff that's done here at Riot. It's super fun and there's just a wide variety. I can be painting a robot one day, then a knight, then some kind of creature. It's nuts. I remember in a previous job it was like a year and a half of medieval stuff. But with the amount of skins and champions in the League universe, it's so colorful. Also, you might see a cosplayer dress up and you're like, "Holy shit, they got that little detail that I put in!" That's a good feeling and I guess it wouldn't happen with personal art.

What do you think separates Riot from other companies?
Previous companies I've worked at definitely want speed. They want quality as well, you know, but the timeline is very important. Pushing back on something because you don't feel like it's the best it can be is harder in other companies than here. Here, people understand.

And what about Riot employees?
Everyone in Riot is passionate about the game. In other jobs I've seen people working on art and they don't even play the game. "Hey, what you working on?" "I don't know, this thing." Oh, man! Here, people are super passionate. They understand champions or other parts of the game and really make something.

We've heard about collaboration and adaptability. How important are those things at Riot?
Very important. I once said to Eric Canete, "That looks so sick. How do you even think of that pose?" He's like, "Well, you know, it's kinda broken – the anatomy." Wait, what? I thought things couldn't be broken. He broke the anatomy just enough to push the gesture even further, and that's why the axe swing looks so much stronger, like it's really going to kill someone. So I try to tweak things and see if there are areas where I can break just enough to enhance the gesture, but so it's not viewable to the human eye.

How does an artist get a job at a studio like Riot Games?
It's beneficial to be well-rounded and try different styles. If you think, "Oh my god, I have to do that, I want to be in that company," then research and see the kind of stuff they're into. It pays off to put more work into that kind of style. That will help you get a foot in the door.

 Alex Flores studied in the Philippines before moving to the US to work at EA as a concept artist for the Sims, then taking a job at Riot Games.
www.artstation.com/alexflores

STUDIO PROFILE

2MINDS

The two-person, independent studio punching above its weight in Brazil

The small concept art and illustration studio 2Minds didn't get overelaborate when coming up with a name. Why be needlessly fancy when something simple works just fine? The Brazilian studio is the marriage of two minds, those of Thiago Lehmann and Luiza McAllister. They have been working together since 2010, their contrasting mix of styles and skills aiding each other.

When they were interns at a design studio, they decided they'd like to illustrate together. The couple quickly established a thriving home studio, with global clients including major advertising firms, as well as concept pieces, game art and fan art. "The initial results were beyond our expectations," says Luiza. "Because our styles were really different, we kept ourselves motivated by comparing the resulting studies every day."

> ❝ We are each other's art director – and we're highly demanding art directors! ❞

One of several characters 2Minds created for its Profundus art book of traditional illustrations.

"After a couple of months, the first client contacted us and we've been working non-stop ever since. We discovered that in combining each of our strengths the results are unique. It also helped us to work faster and improve the quality of our designs, since we are each other's art director for every project we do – and we are highly demanding art directors with each other!"

Although the studio comprises only the pair, they rely on a roster of skilled partners to help out on more complex projects. This is reflected in the studio's portfolio, which displays a wide range of styles and excisions – they are masters of multiple art forms.

Keeping it simple

Having such a simple arrangement does have further upsides: it means the pair can be absolutely clear in what work they take on and what they pass on, as Thiago explains: "We only work on things we are passionate about. And we're always trying to improve."

This constant searching to improve and innovate is a further strand of the studio's portfolio. Within it you'll find client projects mixed with personal work, all of it different, interesting and brilliantly executed. "We love creating and developing our own projects," says Thiago. "We try to bring new stuff to the table – different media, different styles, different points of view. Our personal projects keep us motivated and help us improve our performance in freelance jobs. We're creating new techniques all the time to achieve the results our clients expect."

The studio recently worked with Riot Games Brazil on the Jungle Hunting Season project for League of Legends. They were also commissioned by Alderac Entertainment Group, producing two decks of the new expansion It's Your Fault, four decks for the Pretty Pretty Smash Up expansion, as well as all the artwork for the upcoming game Love Letter.

Behold, one of the cute but fearsome Pet Warriors!

LOCATION: Rio de Janeiro, Brazil
PROJECTS: It's Your Fault, League of Legends, Love Letter
OTHER PROJECTS: Danoninho Dino City, Taptiles Saga
WEB: www.2minds.ws

Another curious character from 2Minds' Profundus art book of oceanic creatures.

2Minds' work on League of Legends character Gromp needed lots of detail without losing established personality.

SAY HI TO GROMP

2Minds worked with Riot Games on the League of Legends character who eats insects... and people!

"This piece gave us a lot of visibility! Working with Riot Brazil and our art directors Marco Aurélio ('Wendigo') and Vitor Ishimura was really nice; we learned a lot from them. The studio was contacted by Ishimura, who already knew our work.

"We were responsible for the three first images to be released for this project: Gromp, The Wolves and Blue. Those illustrations are wallpapers for the Riot players who had to collect some objectives in the game to liberate some achievements and release the arts one by one. We are really thankful and it really made us proud!

"All art was digitally created, from sketches to final renders. We made a few rough sketches with layout ideas. These were the first 'splash screen art' for the characters, so we had to keep them very similar to their in-game models and add a lot of detail without losing their personalities. Since the model was low poly, the biggest reference was the animation cycles for spawning, attacking and defeat. It was a nice challenge with a lot of positive feedback from fans. We really enjoyed working on it."

Do you give me a stroke or not? Another of 2Minds' Pet Warriors.

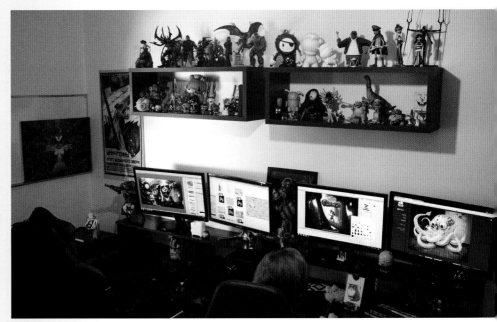

Where the magic happens: 2Minds' studio space is a place of both discipline and spontaneity.

"Previously we worked with Arkadium, creating concept art and character art for the Taptiles Saga game. We also worked with Zombie Studio, contributing to their advertising concept art projects and also developing a big project for Danone Latin America's Danoninho Dino City."

One big con

In 2014 2Minds created their first art book, called Profundus, a traditional illustration concept of oceanic creatures. For the launch campaign they also painted two acrylic pieces and two digital posters. All 250 sold out when the studio attended the first installation of Brazil's Comic Con Experience. The goal for the project was to explore traditional techniques instead of their day-to-day digital work – and they managed that with aplomb. In December 2015, 2Minds published their first comic book, Plumba. The project

> ❝ **The dream is to work with things we love – and maybe get money in the process!** ❞

compared the pair's desire to combine a traditional adventure story with high-definition work, developing different concepts and styles for each chapter. The final result is a comic book that feels like a concept art book.

In terms of workflow, the pair are highly structured to the point of being strict – surprising given the instantaneous and free-flowing nature of their work. "We usually start with a lot of thumbnails and sketchy silhouettes, trying to understand the shapes and dynamics we need to build the illustration," says Luiza. "We send these to the client, so they can participate in the whole project. Every decision is shared."

"This first experimental phase really depends on the client's directions. We start with variety and try to narrow it down, depending on client feedback. Some directors change their minds when they get a chance to see a different angle of something they already had in mind. This process allow us to participate more actively in the creation process, instead of just following orders."

After the central concept is agreed, the pair split the work into two phases. Thiago is responsible for the conceptual ideas. He sketches all projects and creates the final layout and line art for each piece. Luiza decides the color schemes and paints and renders all final art – and does the majority of client communication.

Living the dream

In terms of the future, both Thiago and Luiza are content to see what develops naturally rather than striving after a five-year-plan. "Since we are a couple, our goals are similar, and happily we are aligned in what we are expecting for the future!" says Luiza. "We are really happy with what we've achieved over the past couple of years.

"We hope that in the next couple of years we can still work with board games and digital games and keep the personal work up to date. The dream is to keep working with the independent things we love – and maybe get some money in the process!" ∎

©Riot Games

Blue is another character that 2Minds created with Riot Games for League of Legends.

BRAZIL GOES NUTS

Marvel at 2Minds' Pokedex Project!

Inspired by the Kanto Pokedex Project (curated by 152 artists globally), 2Minds invited Brazilian artists to contribute. The result is this Pokémon character series, each inspired and created with a unique Brazilian flair.

Venusaur (Thiago Lehmann)

Gengar (Luiza McAllister)

Quagsire (Vitorugo)

Sneasel (Bruna Richter)

Pidgeotto (Elisa Kwon)

Wigglytuff (Vinicius Souza)

Croconaw (Caio Monteiro)

Spinarak (Luiza McAllister)

Tyranitar (Thiago Lehmann)

LOCATION: Singapore
PROJECTS: Seika Project, Aether Captains
OTHER PROJECTS: Karate Fight Ninja All-Stars Edition, Nihongo Master, Over the Hills and Far Away, Inori Aizawa
WEB: www.collateralds.com

STUDIO PROFILE

As artists delve into the anime subculture, the personal work area of each is filled with little things that inspire them.

COLLATERAL DAMAGE STUDIOS

Starting life as a local artist group, this Singapore studio is now a global player, as we discover

> **"There is always a mobile games company looking for artists..."**

Based in Singapore, Collateral Damage Studios has quite the backstory. It began in 2006 as a doujin circle – a group of friends who got together to share their work and inspire each other creatively. So how did a loose gathering of enthusiasts, focused on the art of anime, evolve into a fully fledged, commercially successful creative agency?

"It was a gradual process," says projects manager KC Ng. "The group slowly grew in prominence and expanded the circle to include other artists. It was soon being regularly featured in news articles about the indie scene, and we started to get approached to do commissions. We'd even get sent the occasional CV from professional artists."

Fan art fans

But it wasn't until 2013 that the circle took its first steps towards becoming a more formal commercial entity – when Microsoft approached the group regarding a character that had been drawn for fun. The anime-style character, a young girl called Inori Aizawa, had been created as a piece of fan art, after artist and producer Danny Choo had posted an image featuring human equivalents of the Safari, Firefox and Chrome web browsers.

Inori Aizawa is a sassy girl who fights robots, dresses in sexy geek clothes, and pets her cat while surfing the web. Microsoft loved the design, and wanted to use it in its marketing campaigns for Internet Explorer in Asia.

"That was when a couple of the circle's members decided to take the leap of faith and set up the studio," remembers Ng. "Working closely with the Internet Explorer marketing manager in Singapore, Collateral Damage Studios brought together a team to produce an animated short. It went viral, and the rest is history."

TAN HUI TIAN
The CDS senior illustrator on the industry and success

Hello, Hui-Tian. What did you do before coming to Collateral Damage Studios?
I was a game artist at PD Design, and my portfolio consisted of character design, GUI and some environment art.

What's been the highlight of your time at CDS so far?
Being able to set the art direction and helm projects from start to finish, such as the board game Aether Captains, has been exciting. I also really like working with clients such as GoBoiano [the global network for anime fans and creators]. They are open to wilder stuff and tend to set clear art directions as well.

Outside of your day job, what kind of art do you tend to enjoy producing the most?
Currently I'm obsessed with creating fractal art using Mandelbulb 3D, and learning 3D to supplement my 2D art process. I also have a predilection for world-building, though, and I still tend to be more motivated by that.

It's a time of great change in the industry. But where, in your view, is it heading?
I think the industry has really expanded in the past few decades. Pop culture and even certain sub-cultures have become mainstream, and nowadays there's always a mobile games company looking for artists and so forth. There's even the option of crowdfunding now, too, by way of Kickstarter, Patreon and suchlike. It's an exciting time. Some sectors of the industry may be stagnating (traditional trading card games, for instance), but there are entirely new sectors which seem to be flourishing as well. I don't think it's necessarily easier in this digital age, though, because the competition is really high these days as well, with globalization and the availability of educational resources.

Lastly, what advice would you have for someone wanting to be a concept artist right now?
I would tell aspiring digital artists not to go to art school unless they're certain it's going to pay off for them. None of your prospective employers would ask to see your qualifications, and a lot of educational resources can be found elsewhere. Also, hang out with professionals who can offer practical advice. And most importantly, draw what you like and have fun drawing. Life is simply too short to be someone else.

Tan Hui Tian is a senior illustrator at CDS and an experienced game artist who has previously worked for an indie game developer.
www.tanhuitian.deviantart.com

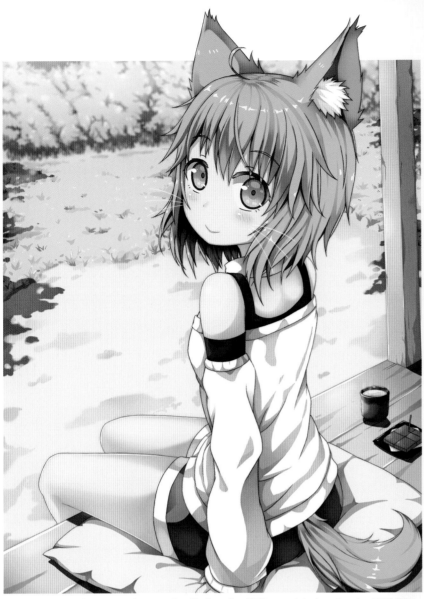

Ricky Li's Eroko made it on to various merchandise based on CDS' own original comic series, MON GIRL.

A still from AFASG15's promotional video featuring SEIKA, who was designed by Low Zi Rong.

A personal illustration by Tan Hui Tian, simply entitled Pale.

Tan Hui Tian and Lim Wei Lun worked on the box cover art of the boardgame Aether Captains, published by MAGE Company.

Since then, CDS has worked with international clients such as Wacom, Faber Castell and Soda Pop Miniatures to create a number of anime-inspired visuals and marketing campaigns. Recently, it's even started widening its scope beyond anime, such as the company's collaboration with board game publisher Mage Company on a steampunk-themed game featuring airships, called Aether Captains.

An animated music video produced for SOZO, the organizer of Anime Festival Asia (AFA), to promote its Anisong [anime song] concert, is another big recent project, reveals KC. "We did the storyboarding and the concept art," he says. "Our resident character designer Low Zi Rong did quite a bit of the key animation, too."

Set apart

A self-trained illustrator and animator, Low is one of the studio's best-known artists, having created both Inori Aizawa and SEIKA, the official character for Anime Festival Asia.

Two things set Collateral Damage Studios apart, he believes: "We're geared more towards a Japanese style of artwork creation. And we're also willing to take on different genres of art, at the request of our clients." Low's highlight at CDS so far has been "being able to involve myself in full 2D animation projects, which is rare in the Singapore scene," he says.

Illustrator Ricky Li is a more recent recruit to the company and is in charge of developing intellectual property such as MON GIRL, an adult comic strip for the Lewd Gamer website, and cultivating the studio's fanbase directly through creative mentor site Patreon. "I was first introduced to the doujin circle by a friend of mine," Ricky says. "After I graduated, I joined the studio full-time." Working on client projects such as My Little Dictator, a visual novel from WarGirl Games, and Nihongo Master, an anime-themed website for learning Japanese, he's come to realize "time management is

FRONT
BACK
logo hairband
swipe address bar glove
swipe down tabs
quick access belt
Karaoke Web Standard

Here's Low Zi Rong's original character design for Aizawa Inori, which launched CDS as a studio.

" You need to accept all kinds of challenges. Passion is crucial "

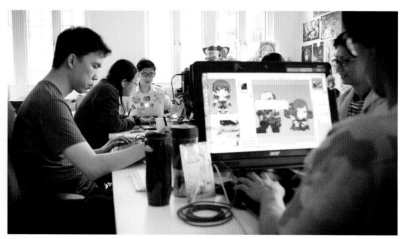

CDS artists hard at work creating more great anime.

METEOR SHOWER
Illustration UsanekoRin

Hoshizora is a personal work by Lim Wei Lun.

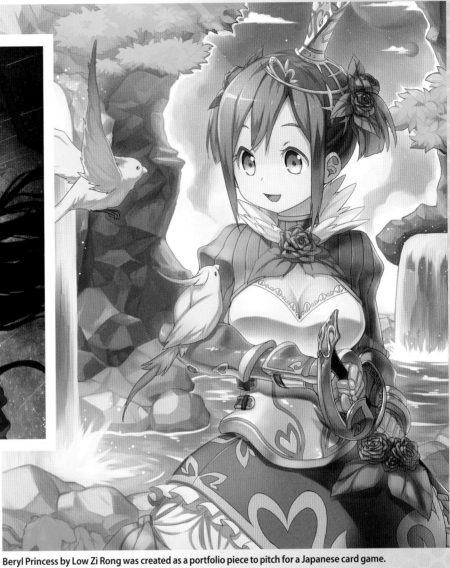

Beryl Princess by Low Zi Rong was created as a portfolio piece to pitch for a Japanese card game.

very important, and if you want to be a concept artist you need to be ready to accept all kinds of challenges. Passion is crucial."

Senior illustrator Tan Hui Tian is another recent hire and an artist who previously worked for indie developer PD Design. "I was freelancing for CDS, so the job sort of fell into my lap," she says. One of the biggest challenges Tan feels the company faces is "the mindset that anime is somehow easier or cheaper than Hollywood-style concept art."

Though artists such as Hui Tian weren't around in the early days, the core doujin philosophy remains a big influence on the company, KC emphasizes. "The team still maintains strong relations with the original doujin circle's members outside of the formal studio," he says. "And when the need comes, we tap into the talent pool of the Singapore doujin scene."

And that relationship isn't just one-way: the studio is also keen to give back to the community and regularly supports ground-led initiatives that promote local illustrators. "We provide expertise to help the organizers of Doujima, a mini art fair for local doujin circles, and Extravaganza, an art competition organized by students for students," KC says. A virtuous circle – and the spirit of the doujin lives on. ◾

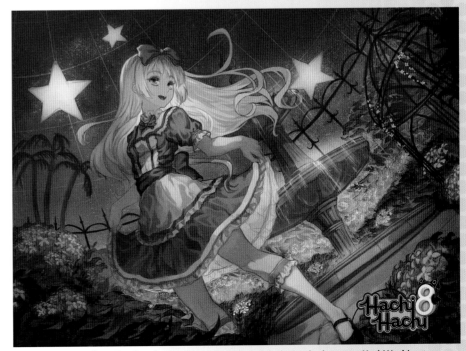

Lim Wei Lun painted Yun Yun Cosmica for Skytree Digital's mobile device rhythm game Hachi Hachi.

ARTIST Q&A

YOUR QUESTIONS answered by our panel of experienced artists

MEET THE EXPERTS...

Sara Forlenza
Italy-based Sara is a freelance artist who works mostly on book covers, digital cards and role-playing games. She also creates illustrations for a range of apps.

www.saraforlenza.deviantart.com

Lorena Lammer
Lorena is a freelance artist living in Germany who works mainly for card games, and pen and paper publishers. She spends a lot of her time entertaining her two cats.

www.lorenala-art.com

Mélanie Delon
Mélanie divides her time between working for different publishing houses and creating her own artworks, which often depict her love of fantasy characters and scenes.

www.melaniedelon.com

Bobby Chiu
Bobby lives in Toronto and works in the film industry, painting fictional creatures and characters. He founded Imaginism Studios and teaches art at Schoolism.com.

www.imaginismstudios.com

NEED HELP?
Your questions are answered in every regular issue of ImagineFX. Email help@imaginefx.com

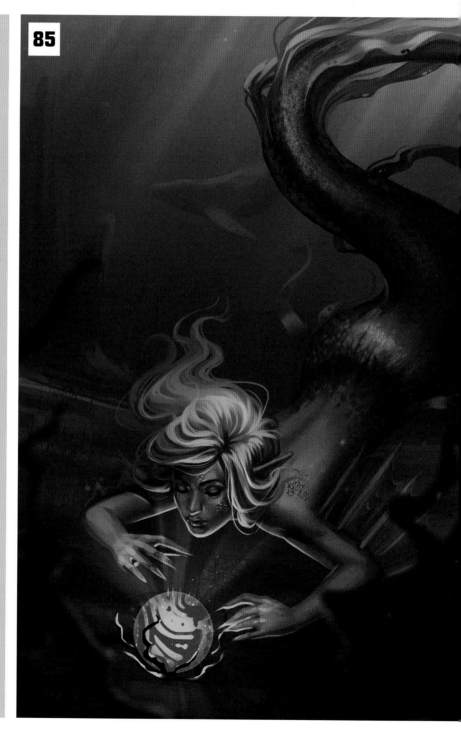

85

89

86

82

86

ARTIST Q&A

Although the overall emotional state is sadness, I've painted three rather different facial expressions.

QUESTION:

How can I show a small group of people in different states of emotional distress?

Barry Carter, US

ANSWER: *Sara replies*

Painting a person's emotional state is a difficult skill to master, and you'll need to invest a lot of time studying people's faces, their postures and mannerisms, to be able to produce a credible painting on this theme.

I would also suggest keeping a mirror close to your painting workstation, so that you can watch yourself acting out different emotions. Better still, you can touch your face to feel your facial muscles as they became contracted if you're acting out anger, fear or despair, or became relaxed if you act out joy or a relaxed state of mind.

If we take as an example the emotional state of sadness, there are various levels that can be represented, ranging from melancholy to despair. And for every emotional state, a person's body language and facial expression changes, too.

Sadness is an emotion that can manifest itself through crying. Other body language for sadness may include sloped shoulders that are closed in on themselves, a curved back and lowered head. Similarly, the facial features tend to go downwards: the sides of the mouth and the corners of the eyebrows can all droop, for example. Once you work out how to represent the emotion of sadness, you can add drama by using light, shadow and the general atmosphere to emphasize it.

ARTIST'S SECRET

Focus on the eyes
I pay particular attention to the expression of the eyes, because the viewer will be attracted to those. So I remember to paint reddened sclera and any little wrinkles around them, to enhance the sad countenance.

STEP-BY-STEP:
Portraying different upset emotions

1 I want to paint a desperately sad figure, who is resting his head in his hand. Face muscles contract during a period of crying, so I paint a furrowed brow, eyes that are squeezed tight and a wrinkled nose. I also give him grinding teeth, to suggest the sense of anger often present in the moment of despair.

2 Here the character has cried a lot, so I give her red eyes and nose. Towards the edges of the eyes I add a few touches of light to suggest skin that's still damp with tears. The facial features are less pronounced compared to the previous step. I paint running makeup with black brushstrokes on an Overlay layer.

3 This character's emotional reaction has evolved into a kind of concern. So her face will seem apparently neutral. Only the eyebrows are stretched horizontally with hints of a frown, and the eyes will be wide open. If we want we can play with the reflections in the iris, where white brushstrokes suggest unshed tears.

QUESTION:

I'm keen to realistically depict repeated elements in a scene. What's a good technique to use?
Kate Kudrow, Italy

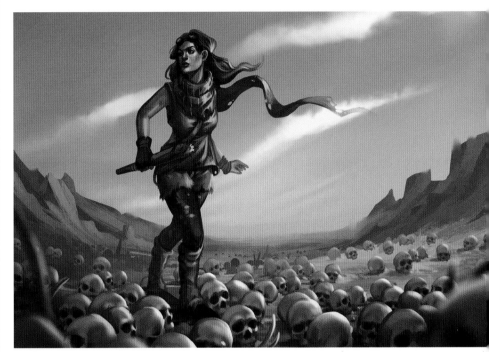

All skulls are based off four different ones. To introduce more variety I add some round shapes in the distance and in between the skulls.

ANSWER: *Lorena replies*

Sometimes, when working on a painting in Photoshop we need to have several copies of the same object in a scene. Yet painting each and every one would take up a lot of time. Fortunately, there's an easy way to achieve this in a couple of minutes.

The best way to go about this is to draw the item you want to repeat on a new layer. If you have a direct light source affecting it don't worry about that until later. For now, just paint the item with ambient and reflected light. Then select the Move Tool (V), hold Alt and drag. This way the item will be duplicated on to a new layer. Repeat this process as often as you need to. You can also flatten a couple of layers at some point and use the same trick to repeat the object even faster. While doing this, be mindful of the layer order and use the Transform Tool to change the sizes and direction of your item.

When you're done with the repeating process, lock the transparent pixels of the layer your objects are on (on your Layer panel click the square icon that comes directly after Lock) and paint in the direct light. If you want more variety in the way the items look, you can now paint in details that will make them look different from one another.

These are my four basic skulls, each of them sitting on a different layer. I can now make copies and transform them to fit the image, before adjusting the lighting on them.

ARTIST'S SECRET

Use shortcuts
Photoshop's default shortcuts are always going to save you time. Even better, make your own for the tools or actions you use most. For this, go to Edit>Keyboard Shortcuts and set them up. Doing so will make your workflow much faster – once you get used to them, of course!

QUESTION:

Do you have any tips for painting a still life practice piece?

Geneviève Harquin, France

ANSWER: *Sara replies*

I'd always recommend setting some time aside for a still life painting session. You'll learn realistic rendering techniques, meaning you can paint credible details and create a more intricate illustration. It's also useful to keep your eye trained to capture colors, shades, proportions and to learn how to paint inanimate object like fruit, cloth, and glass and metal objects.

For this article I put together a composition using the glassware, a jug, a wine glass and an ornamental glass. I place them on a white table cloth, close to a source of natural light, so that the way the light interacts with the glass is obvious. Before starting the painting I take a photo: sunlight changes its position and color during different times of the day, so it's better to keep a reference image because the work can take a long time.

Since my purpose is to portray a still life composition, I don't worry about the background. I simply sketch some lines to outline perspective and table top, bearing in mind that its color will affect the lights and shadows of the scene.

When I practise, I choose to portray materials such as glass, to bridge the technical gaps in my knowledge.

To get the most from your still life session, ensure your light source hits prominent objects in the composition.

ARTIST'S SECRET

Painting perfect glass

Glass is transparent, but it's vital to remember that what we see on transparent surfaces will be distorted by the glass forms. So don't paint with too much detail – it's enough to define only some areas.

STEP-BY-STEP: Sketching and adding details

1 I proceed as I would do when painting traditionally. I start with a quick sketch of the jug and the two glasses with a small, hard-edged brush, bearing in mind proportions and perspective. Drawing diagonals on the canvas helps me keep the composition's key elements in focus. Once I'm happy with my sketch I lay down basic colors using the Lasso and Fill tools.

2 This is a delicate phase because choosing colors similar to those that our eye perceives can really make a difference in the success of my painting. Of course, working digitally means I can easily correct my colors, unlike with traditional techniques. With a large hard-edged brush I sketch lights and shadows, noting that with a cold light I have warm shadows tones.

3 I add details. First I define the cloth with a smaller, softer-edged brush. I paint darker shadows where the fabric overlaps. Before moving on to glass objects, I paint the light reflected on the fabric folds, picking up the color with the Eyedropper tool from the well-lit areas of the wine glass (which in this case is a bright and saturated red) and the water jug.

4 I paint the glass and the jug on a new layer, using the Eraser tool to create the transparent effect. As well as being transparent, glass is also reflective so I create another layer and I paint the reflections of the drapery on the wine glass. I use a brush with a soft edge to avoid overcooking them. Finally, I detail the objects and paint the blue lines that run across the cloth.

Though the light won't travel very far, you can use an unnatural light source to put the focus on a specific part of your image.

QUESTION:

Help me illustrate an underwater light source

Jim Curtis, England

ANSWER: *Lorena replies*

Light behaves differently underwater than it does above it, which affects not only the lighting of a scene but also the colors. The first thing you have to keep in mind is that because water is much denser than air, light doesn't travel as far and thus doesn't illuminate the environment as it would out in the open.

As for the color, everything receives a blue or green-ish tint and the deeper the scene is set in the watery environment, the more intense and darker this becomes. That's why deep in the ocean you won't see a lot of red, if at all. Keep this in mind when painting!

Decide on what kind of light source you want to paint, and experiment with Layer and Brush modes to create different effects. Soft Light and Color Dodge can help you achieve interesting glowing effects. Red light is very rare in underwater environments, but it can attract the eye, so try it if this suits the scene.

If you want to keep things straightforward, a teal or blue light source will enable you to light up your focal point more easily.

1 I start off with a rough sketch and some colors, to see what direction I want to take the illustration in. At this point I have four layers: the background, the sketch, the flat colors for the mermaid and the light. Separate layers make it easier to make adjustments. Later on you can flatten the layers as you see fit.

2 Keep the mood of your picture in mind. To make the most of your light source, keep everything around it rather dark. Tweak this effect by making use of Layer Adjustments (Image>Adjustments) to darken or desaturate different parts of the image or by using Layer modes, such as Multiply, and a Soft brush.

3 I kept the direct light on a separate layer until now. Once I'm happy with the colors in the scene, I flatten everything down and start detailing the face and the parts that are illuminated by the sphere. I also put more work into the light source itself and add the rays of light on a Soft Light layer on top.

QUESTION

What are the basics of good character design?
Devin Tucker, US

ANSWER: *Jia-Ying Ong replies*

There are several ways to approach character design; there's no fixed process that you must adhere to. And rather than dwelling on the effectiveness of the finished art, I recommend simply enjoying where that process takes you.

I often begin creating a character from scratch by branching out ideas from a specific source of inspiration. Start small scale with thumbnail sketches and rough poses to convey the general form. Not having to worry about details will also give you more options. In the example, I chose to create a more or less neutral character (a supporting role, like a particularly flashy shopkeeper in a mystical underground district) drawn from Asian folklore.

Next, do some research. This will help interpret the form in a way that's believable, by borrowing elements from existing design or being inspired by them. If your inspiration stems from one main source, don't just limit yourself to that: look up subjects that are unrelated yet can help to enhance the concept. For this example, I base the golden swirls loosely on antique china tea set patterns.

For cohesiveness, I repeat colors, patterns and overall concept throughout. Using a single color more than once, while maintaining a relatively strong contrast, makes certain elements pop. Bear in mind that details shouldn't be littered throughout the entire form, but concentrated on specific areas to avoid confusing the eye.

To round them out as an individual, factors such as your character's posture, fashion choices and even favorite objects should reflect their personality or lifestyle.

 ### ARTIST'S SECRET

Shape it up
Photoshop's Pen Tool can help with keeping pattern lines polished, while using a basic Soft brush will create a rougher, painterly effect. Go with whichever you prefer for the look you want.

I usually stick with a maximum of four base colors that work well together, while keeping the design clean and simple.

QUESTION

My manga characters' hair never looks right. Where am I going wrong?
Alice Daniels, England

ANSWER: *Jia-Ying Ong replies*

Hair is always a tricky component to any character drawing. Whenever I begin a portrait, I usually have two key things in mind when it comes to the hair: the start of the flow (establishing the point of origin on scalp), and its overall movement – will it stick up in all directions or form a gentle slope down the character's neck, for instance.

Planning the flow and movement, and making it convincing to the eye, may seem like a challenge at first. Start off by looking at hair in simple sections, as opposed to attempting realism by painting every strand – which is a pretty respectable talent on its own, but not quite what we're looking for in manga style. Details like hints of stray strands can be added in later on.

As crazy as some manga hairstyles can get, it's important to play between fantasy and reality carefully. Essentially, what we're looking for is to create a believable hair structure that will not only complement the character's face, but also help in giving appeal and identity.

Focusing on separate portions of the hair instead of fussing over details simplifies the process.

VIDEO
AVAILABLE

QUESTION

My magic wand effects don't look particularly magical. Any advice?
Martha Sokolowski, US

ANSWER: *Mélanie Delon replies*

Here I choose to paint a basic magic effect, but the possibilities are infinite. I begin by choosing a suitable color for my magical ray of light. I want my character to be very girly, so I pick a bright pink, after disregarding yellow. I use this color to lay down the base of my magical effects, by creating a huge glow of light on the top of the wand, and a long curly ray/wave – like a shooting star, for example – all around the character. This ray follows the trajectory of the wand or the direction of the magic spell that's being cast.

Because I want the light wave to be diffuse I use a custom brush that's very soft and textured. You'll find it among our resources – see page 146. You can also play with the Layer Opacity or mode to generate more cool color effects. Here, I erase some parts to achieve the perfect render.

I also work with different shades of pink, to enhance the magical look and also to bring in more texture. I mix a pale pink with a deep pink and create some extra waves over the ray of light.

The top of the wand will be the brightest part, so I ramp up the visible light here. Finally, to increase the magical effect, I add sparkles around the wand and the wave. I use a precise brush to do so, with sharp edges to generate marks that are neat and well defined.

The wand's light must affect everything around it, in this case the spellcaster's face and clothing. So I add more pink light to her jawline and lips.

I tend to add a lot (maybe too much!) of sparkles and effects when I paint magic in action. Adjust such visuals to suit the story you're telling.

ARTIST'S SECRET

A wave of magic
I use a custom brush to create the magical curly wave, which I also use for smoke. I like this brush because it's a kind of two-sided tool. One side is very soft and diffuse, while the other is more precise. This is perfect for adding definition and details to the wand's magical effect.

STEP-BY-STEP: Paint manga-style hair in sections

1 I sometimes sketch out the bald head underneath beforehand, to give myself a rough indicator of where to establish the hairline. I always try to draw hair in thick masses, taking note of the point of origin – in this case it's roughly the top left of his scalp.

2 I drop the sketch layer's Opacity and use it as a guide to paint underneath on a new layer. I treat each section as a clump of hair, rather than single strands. Clumps create shadows over others; I play around with this, and make sure there's enough volume and credibility.

3 I use lighter values of the hair's base color to add details, such as thinner sections of hair. This gives a more natural look, while also giving the impression of being slightly disheveled. I add a thin, dark outline, and deepen the shadows that the hair casts over the face to introduce depth.

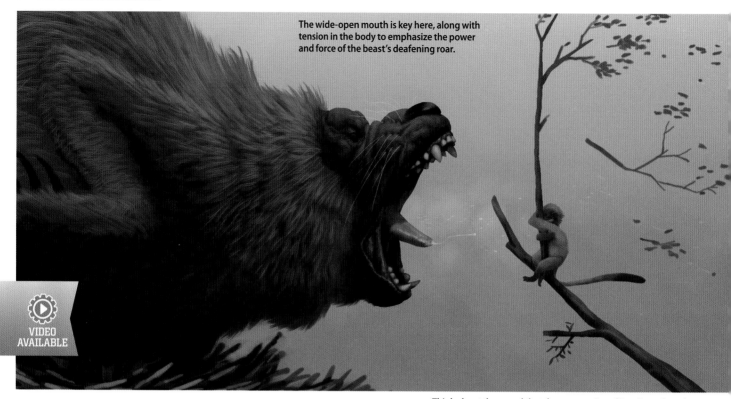

The wide-open mouth is key here, along with tension in the body to emphasize the power and force of the beast's deafening roar.

QUESTION:

Please help me show a creature that's roaring

Bingo Little, US

Think about the sound that the creature is making. Even though nobody will hear it from looking at a picture, this detail will flesh out your story, which will inform the subtleties that will give your image life. Subtleties create a sense of believability.

ANSWER: *Bobby Chiu replies*

Many actions and emotions can be thought of as either energy expending or energy conserving. For example, yelling, cheering and anger expend energy while sleeping, hiding and sadness conserve energy. Energy-expending actions tend to stretch one out, like reaching, pulling. Energy-conserving actions, by contrast, tend to compress one in: huddling, curling, squishing into a ball. These are the basic principles I keep in mind when approaching a mighty roar.

A big part of successfully showing the emotion in a roar is effectively exploiting lines of tension. What's moving when the subject is roaring, where are these parts located, and what anatomy restricts them from moving any further? For example, on a roaring or yelling person, the mandible hinges at the top and pivots down from the palate as far as it can go until the muscles and skin covering it prevent it from opening any further. These opposing forces – the mandible trying to open and the cheek muscles and skin preventing it from doing so – are what cause the stretch. Naturally, the greater the opposition of these two forces, the tauter the stretch. Looking for these lines of tension and stretching them out to straight lines will exaggerate a good roar.

STEP-BY-STEP: Did you hear that?

1 I emphasize the lines of tension around the mouth area to exaggerate the force of the roar. There's no better way to communicate stretching than with straight lines, which clearly say, "Any tighter and this thing will snap."

2 As the mandible pulls away from the palate and the mouth stretches open, the flesh and skin above and below the mouth should wrinkle and bunch up. You can see that the front of the muzzle is accordioning in multiple directions.

3 Think about motivation and emotion, and try to show that in every part of the body. I have my creature's shoulders up and arms back, elbows up to communicate force going forward. The mouth is open as wide as it can go.

VIDEO
AVAILABLE

QUESTION:

How can I portray mixed emotions within a group of people?

Jon Douglas, England

ANSWER:

Sara Forlenza replies

To answer this question I decide to draw a group of friends who are gathered on a couch in front of a television to watch a horror film. The viewer won't actually see what's on the screen, and so this means that I can concentrate on developing the characters' different facial expressions and not worry about having to depict what they're actually watching.

I start by sketching mixed figure poses sitting on the couch. For the moment I don't pay too much attention to the anatomy and instead focus on the naturalness of the poses. When I'm relaxing at home, my back is rarely straight and my legs and arms are never folded; why should my collection of characters be any different?

I place the television on the right-hand side of the image because I anticipate that the painting will be seen from left to right, so that the viewer has plenty of time to take in the faces of the various characters.

Once I'm satisfied with their poses, I produce the final sketch and add various details to the environment: popcorn, a cat and a dog. I choose a night-time setting, because it fits well with the horror film choice. What's more, the dark colors contrast nicely with the light that's coming from the television, and this will help me focus attention on the characters. I don't go into too much detail in the background because this could prove a distraction. Instead, I focus on their faces and paint their expressions.

I want each character to have a different personality, and so it's important to vary their expressions.

Here's a rough sketch showing only the posture and anatomy of my figures, which helps me see if the image is balanced.

ARTIST'S SECRET

Light from a television
To create the correct lighting setup in front of the television set I use a cool spot light that originates from the screen. This casts very dark and contrasting shadows across the entire environment.

STEP-BY-STEP: **Different expression for different characters**

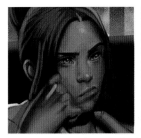

1 I paint the bored-looking character and I focus on her posture, which will communicate her state of mind. The character is holding her head with one hand. Her eyes must indicate lack of interest, so I draw them half-closed and tight. A mouth with drooping corners is essential to show that whatever she's watching is not floating her boat.

2 For the couple, I paint him sitting with his legs wide apart and calm facial expression. I paint his eyes open and mouth relaxed into a smile. But she's frightened and so I paint her huddled with her knees toward her chest and an arm holding on to his shirt. Her gaze must indicate anxiety, so I depict her hiding her head between her shoulders.

3 Now I paint two characters who are interested in the film. The man is concentrating on the plot, so I paint a neutral expression on his face but draw his torso bent toward the screen, as if he wants to see things more clearly. The woman is amused by the film, so I paint her with a big smile, round out the cheeks and widen her eyes.

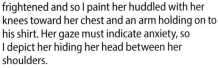

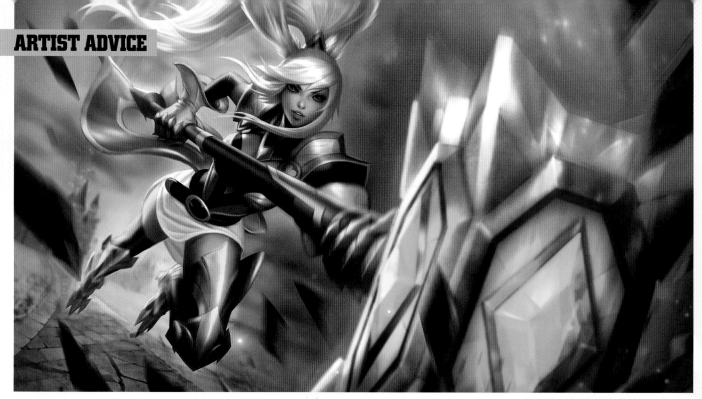

Behold, Alicia the Smasher Bunny wielding her oversized hammer and smashing it forcefully into the ground.

QUESTION

I want to paint a character in a dynamic action scene – can you give any advice?

Hayley Singh, England

ANSWER: *Michelle Hoefener replies*

If there's a lot going in an action scene, such as a warrior wielding a large hammer in battle, then I find it helpful to break the composition into standalone elements and solve them one at a time. First, I decide how I'd like the character to be holding the hammer and what I want them to be doing with it: swinging it, smashing something or someone with it, and so on. In this early stage I draw out the pose from the side to better understand it, before drawing it in perspective.

Next, I decide what kind of character is wielding the hammer, and the type of armor they're wearing.

Once I have the pose, type of character, and their armor design finalized, I sketch out the pose and character in perspective and decide what angle I'd like to view the character from as I'm sketching it out. I then build up the individual armor elements on to the character, and add motion effects, and flying rocks and dirt to show the hammer smashing with great force into the ground.

Painting a perspective-heavy composition can be tricky, if you haven't got a grasp on where all the elements are located. I draw it out from the side first, so I fully understand the character's pose first.

STEP-BY-STEP: **Illustrating a dynamic action pose**

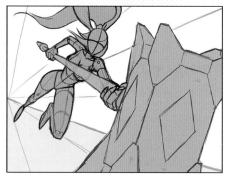

1 After drawing the basic side-on view, I sketch the character's basic pose at a dynamic angle. I also draw in the basic perspective lines for the scene and the horizon line, so that I have a good idea of the camera angle, the composition, and where the character is located in the type of scene that I want to illustrate.

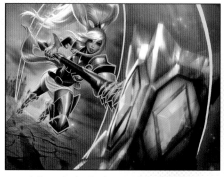

2 I draw the basic shapes of the figure's armor, and the hammer's motion arc. I separate off the main parts of the warrior, weapon and background into masked layers by creating new layers for each, selecting the areas and filling them in with the Paint Bucket tool. Then I block in the lighting and rendering on each layer.

3 I then add motion effects such as blur to the hammer and the character's arms, legs and hair to show the character jumping and swinging the hammer. I select the flying rocks that I want to blur with the Polygon Lasso tool and go to Filter > Blur > Motion Blur. Then I choose the angle and amount, and click OK.

QUESTION

Can you help me apply manga styling to an everyday motor vehicle?

Jason Holifield, US

ANSWER: *Michelle Hoefener replies*

Applying manga styling to a vehicle such as a car or a motorbike can easily be achieved with good reference and creative problem-solving. I first collect references of the vehicle I want to depict from stock websites like shutterstock.com, and manga versions of that vehicle and any other manga references that will inspire the design. At this stage I also think about what themes I want to use for the vehicle design.

Then I start sketching out different black-and-white ideas for the manga vehicle, thinking about value, silhouette and unique iconic shapes. Once I have the first round of ideas sketched, I pick one and sketch it out more, working in black-and-white and with silhouette and value. I then do different color explorations for the chosen design, thinking about the types of colors and color schemes that would fit for the type of design I'm going for and the type of character that will ride this vehicle.

Once I've decided on the final design and colors for the vehicle, I refine, render and light the final design, focusing on final polish and materials.

Here's the final refined and lit shoujo manga style bunny motorcycle.

ARTIST'S SECRET

Extra Theme References
It can also help to draw reference from other Japanese subjects, such as cartoons or video games. Some of the themes that I used for this project were cute chibi bunnies and cats, bright stars, and any other cute manga shoujo themes or ideas.

STEP-BY-STEP: **Concept a vehicle that's manga through and through**

1 I collect references for the vehicle I want to design from stock photo websites such as shutterstock.com. I also collect any other manga references for inspiration. I think about what direction I want to take the design of the manga vehicle in, and consider who the driver or rider will be of this type of shoujo manga vehicle, which should appeal to a teenage girl audience.

2 Next, I sketch out the first set of different ideas for the manga vehicle. I think about many different kinds of ideas during this first phase of iteration. I also work in black-and-white and think only about value, shape, and iconic silhouette at this stage. Once I have sketched out the different ideas that I want, I choose the final idea that I want to explore further.

3 Next, I do more black-and-white value concept iterations of the chosen idea. I put together elements that I like from some of the other concept sketches and unify them into new variations for the chosen idea: the manga bunny motorcycle. I select some of the elements to use from the star motorcycle and cat motorcycle to create more versions of the bunny bike.

4 Once I've finalized the bunny motorcycle design, I produce different color schemes for the design using bright shoujo colors. I then settle on a final color scheme and render, light and refine the final concept. I create a new black layer, set it to Color Dodge mode and start painting on that layer with a light color to add in quick lighting and metallic highlights.

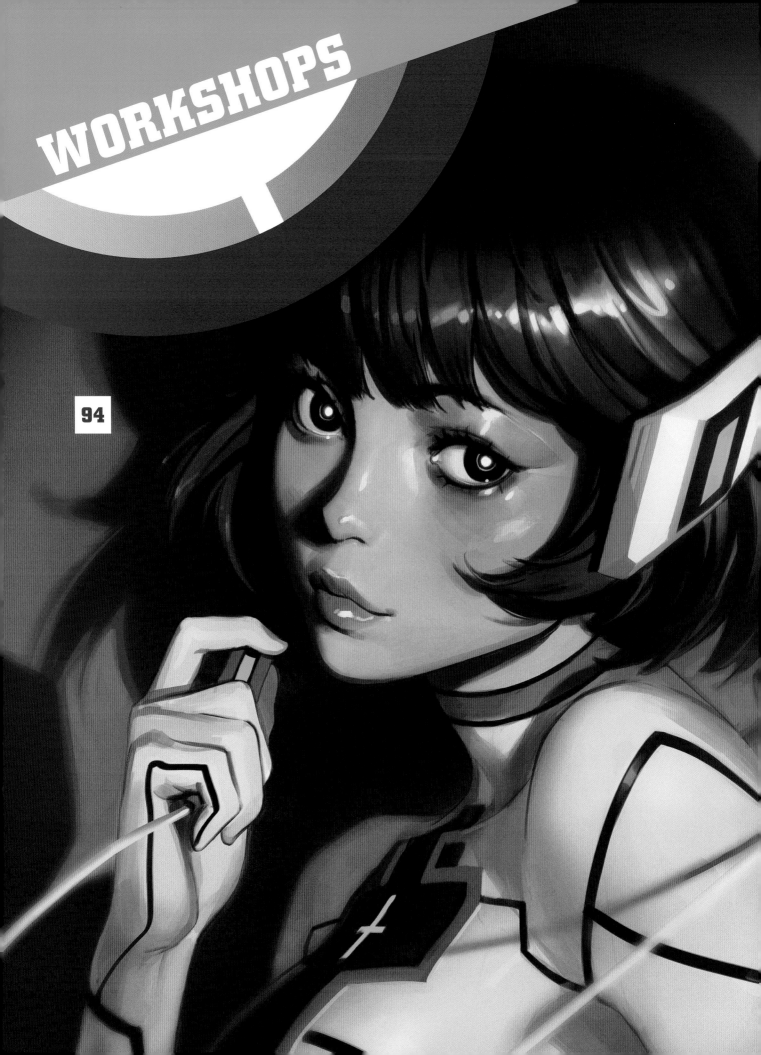

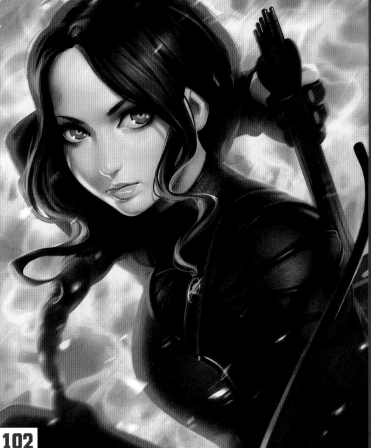

GET YOUR RESOURCES
How-to video tutorials, custom brushes and more! See page 146

PHOTOSHOP

PAINT A MANGA FIGURE ON THE GO

ILYA KUVSHINOV sets aside his normal painting process and instead learns to develop a character illustration idea as it's being painted

ARTIST PROFILE

ILYA KUVSHINOV
LOCATION: Japan

The Russian illustrator and comic artist draws girls for a living and dreams of owning his own animation studio. He's the happiest person ever, he says. http://ifxm.ag/kuily

GET YOUR RESOURCES SEE PAGE 146

VIDEO AVAILABLE

ARTIST INSIGHT

Archive your art's progress
It's always helpful to revisit your previous steps from time to time, to see what's changed and how. I use a program called Screensnap (www.screensnap.org), which saves a full-size snapshot of a WIP to the folder of your choice. I'm sure there are other free options available online.

When I start an illustration I usually have a finished image in mind. So I then do all the steps I need to do to ensure my art looks as close to the image in my head as possible.

Isn't that kind of boring? Yes, you could say that. But here's the good news: that's not the only way to work on an illustration (although it is the fastest way). How about I try to develop my illustration on the go,

upgrading it with every step, always thinking about what I want to show, and how to improve it?

I don't do it like this very often, but that's what will make this workshop more interesting. Right now, you can see the final image on the cover of this cool magazine, and see all the steps here. So everything might look kind of logical. But when I was doing it, I had no idea where it was heading. All I wanted was to do something really cool, something close to ImagineFX's style and

something you'd really like to see on the cover and read about the creation of it inside.

I always think about what kind of character I want before I start to draw it. For example, what's his or her past, favorite food and current mood? What's the situation in which the illustration takes place and how is it going to develop in the next few seconds? For now, let's see how the character develops by herself on the pages of this workshop!

1 A girl and her headphones
My brief is to paint a manga-style woman with one hand on view, maybe wearing some cool hi-tech headphones. It's the headphones that give me my first idea. Music is a key part of our lives, and everybody listens to it in one form or another. So the first roughs feature a girl who simply enjoys listening to music.

2 There's more to media than music...
The next idea that comes to mind is the nature of modern media. She's not necessarily listening to music: it could be films or VR video games, because's everything wireless. So these two sketches are much closer to something sci-fi than the first two, including fantasy costumes and futuristic shapes.

4 Getting to know her

I choose the girl with futuristic headphones, so I start to think more about her. What kind of music is she listening to right now? What's her name, where does she work, what's happening at that moment in the scene? I don't need to finalize everything at this point, but it's good to make a start.

3 Time for my character to relax

For the next two sketches, I return to the first idea of showing the headphones, but in a more relaxing scene: a girl lying on a sofa, with pillows, CDs and a smile on her face. I like the sketches equally, so it'll be interesting to see which one of them I'll be working on.

5 Lines and shading

My rough lines start here. I have an ImagineFX cover template layer on top of the others, so I can easily check the composition. And for cases like this one, I use guides to get all the shapes and vectors exactly right. The face is the centre of focus, so the hand and body help guide the viewer towards this. One of the most fun parts of this illustration is doing the shadows. I really want to use accent lighting – and that's where the idea comes to me: it's a photo session. Perhaps the girl is some kind of celebrity? If so, do her clothes need to look fashionable, or is she doing the shoot in her work outfit?

ARTIST INSIGHT
Get blending
Blending modes are fun! There are some modes that I use all the time for painting and finishing (such as Color Dodge, Color Burn, Saturation and Hard Light). But sometimes I experiment with modes that I don't know so well. It helps to understand how they work, and sometimes you can create some unexpected effects.

SHORTCUTS
CORRECT COLOR AND TONE
Ctrl+U (PC)
Cmd+U (Mac)
Use this for fast color and tone correction on your layer.

RESOURCES
Workshop Brushes
Photoshop custom brushes:
BRUSH ELLIPTICAL

This is the main brush I use everywhere – in sketches, painting, detailing… everywhere!
SKETCHY

A more painterly-looking brush with texture and more variety. I use it mainly for hair.

6 Color and costume
Next up is colors. I merge the lines and shadows layer and set the Blending Mode to Color Burn. This keeps the shadows in place and so I just need to carefully add normal colors. One picture here is with a Color Burn layer (A), the other is just a colors layer without shading (B). As I'm adding more details I start to thinking about her costume. I've got it! I think she's a DJ, playing electronic music. So I want her costume to feel digital and futuristic, but not too robotic or crazy (C). You can see my first rough of the costume here, but I later ditch this look because it's resembles a mech power suit. (D).

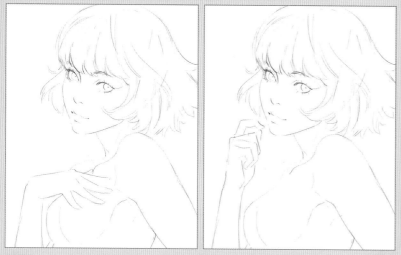

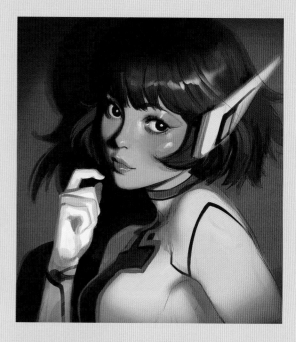

7 Rejigging the position of the hand

I have to change the girl's hand gesture for the overall composition. So I propose two new versions: one with the girl resting a hand on her chest, one where she's holding a DJ tool known as a player, higher up. We decide to go with the higher one, so I repaint the hand.

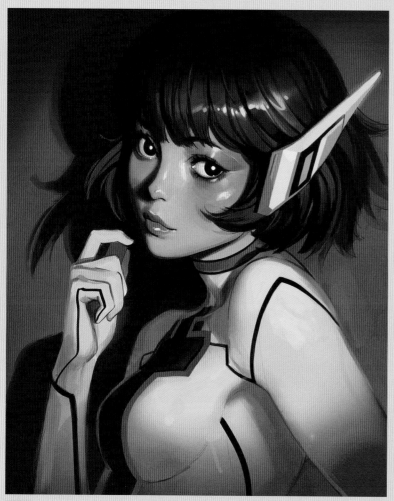

8 Adding details to the composition

Next I start detailing the picture on a normal Blending mode layer – just painting over the girl's face, hair and headphones, with the aim of adding more depth, colors and texture. I also refine most of the edges and introduce more make-up to her face. We decide it will be an unusually colorful cover image. This is where the art starts to look more like a finished cover.

9 Important upgrades

I try to check my illustrations for consistency at every step of the painting and in doing so I realize I've added a hand but forgotten to add its shadow. I also decide to bring in a cast shadow on the right to tonally align the composition, and paint in more details on her outfit.

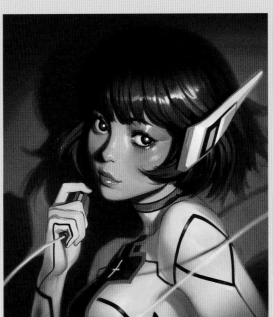

SHORTCUTS

MERGE LAYERS ABOVE
Cmd+Alt+Shift+N & E (Mac)
Ctrl+Alt+Shift+N & E (PC)
This is handy for adding a filter and editing it with a mask.

10 **More refinements, including adjusting the character's jawline**
Because I've added tones and colors, the figure now doesn't resemble the original sketch. In particular, the girl doesn't look as feminine as she did earlier on, so I reduce the size of her jaw slightly. I also add glow on the shadows and other costume details.

11 **Apply Lens Blur and Color Dodge**
It's nearly finished. I merge the painting into one layer and apply a Lens Blur filter. Then I add a Layer Mask to it and erase the parts that I want to stay sharp, such as the focal points, face and hand. To give the cover a more glossy and shiny feel I use a new Color Dodge layer for the hair, face and costume.

12 **Finishing up the artwork**
After painting in a few more small details (such as a little shiny cross on her chest), it's time to add my finishing touches. I add a texture layer (on a new Blending Mode, with Opacity at three per cent), make use of the Curves tool and Selective Color Adjustments layers, and apply the Grain filter. And we're done. So everything about this cover was decided on the go – and it was fun! The problem is, I still don't know what the girl's name is… ∎

GIVE YOUR CARD ART A FEEL OF LIGHT AND ROMANCE

DONG-WOOK SHIN shows how he utilizes light to develop an emotional moment between the king of the jungle and an unsuspecting princess…

ARTIST PROFILE

DONG-WOOK SHIN

LOCATION: South Korea
Dong-Wook Shin, aka Bluezima, has been creating video game art and illustrations for more than 10 years.
artstation.com/bluezima

GET YOUR RESOURCES SEE PAGE 146

RESOURCES

Custom Brushes
INK BRUSH

I use this brush for sketching – the larger its size, the more transparent ink effect it produces.

FAN BRUSH

I painted most of the picture with this, my favorite. It has a texture effect that's smooth, with Pressure Control.

This image was designed for the card game Legend of the Cryptids. I'd recently read the story of Henry VIII and an idea came to me from that. What about painting a tyrannical King Lion who, for emotional contrast, is pictured next to a young girl? The story developed further…

Nobles from neighboring kingdoms have gathered to see the King Lion, at his request, who will announce his new bride at a banquet. The animal guests are surprised when he reveals that he plans to marry a princess from the human kingdom – and the princess had no idea of his intentions, either. The animal guests respond with surprise, while the princess isn't particularly keen on the idea.

When I pass my initial sketch on to show the art director, he says that while the Cryptids' current cards are generally dark, he suggests aiming to create a card with a bright feel. This was kind of an adventure for me. Overall, I tried to create a fairy tale atmosphere, as well as a light touch to help depict a realiztic portrayal. The work was very highly saturated, to give a refreshing feel, with warm colors.

I was told that sales of the image were quite good, as was the reaction from the card users. It was encouraging to receive such positive feedback. ■

How I develop…
AN EMOTIVE FAIRY TALE SCENE

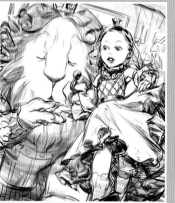

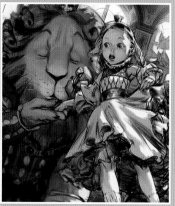

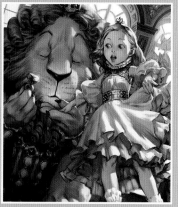

1 Monochrome sketch
I picture the King Lion when he proposes the idea of marriage to the princess – as he pulls out the ring – and this determines the positions of the characters in the composition. I also concentrate on drawing a suitable loving expression for the King Lion and the princess's look of surprise.

2 Color and light
I want the King Lion's colors to be authoritative, while in contrast the princess symbolizes purity, with the help of a white dress. I allow incoming sunlight through the window to warm the scene, and I take further advantage of the blue sky by using it as the reflected light.

3 Describing details
I modify and supplement the more detailed parts of the painting, adding definition to some other parts as I work my way around it. I also adjust the position of the hand holding the ring, so there's a good balance of color. I also tweak the design of the characters' clothing in places.

REFLECTED LIGHT
The blue sky reflects light back on to the characters. This type of reflected light atmospheric helps figures in a composition to look more vibrant.

TRANSMITTED LIGHT
The transmitted light passes through the transparent or semi-transparent material and affects the object underneath. This is mainly determined according to the color of the light passing through the medium, but can be brighter because of refraction.

HIGHLIGHTS
This is the point on the princess that's the most saturated. Here, the clothes are wrinkled and folded, and where the shadows and highlights cross it creates a violet color where the warmth of sunlight and the cold of the reflected light meet.

CHROMATIC ABERRATION
I work on the chromatic aberration – a phenomenon often associated with the camera lens and distorted light – by modifying the red channel and making it slightly larger. This helps to bring the viewer's eye into the center of the screen.

PHOTOSHOP

TAKE A 3D-LIKE APPROACH TO ART

ILYA KUVSHINOV reveals how treating a painting just like a multi-layered 3D model helps him portray Katniss Everdeen from The Hunger Games films

ARTIST PROFILE

ILYA KUVSHINOV
LOCATION: Japan
A freelance illustrator and comic artist born in Russia and trained at the Russian Academy of Arts, Ilya now lives in Yokohama. He aims to create inspiring stories.
http://ifxm.ag/ilya-k

VIDEO AVAILABLE

ARTIST INSIGHT
The Selective Color tool
A very useful adjustment I use all the time to tweak colors is Image > Adjustments > Selective Color. With this, you can edit tones and colors separately – for example, you can make your lights and hotspots more blue, your midtones more red, and your shadows more green. You can also apply it as an adjustment layer by clicking the appropriate icon at the foot of the Layers panel.

You can approach digital painting a number of ways. Some like to paint as they would traditionally, while others base their art on photos or CG renders. You can also use your tools in any way you like, creating new visual styles and working processes.

Yet even working digitally, there are limits to how you can adapt your art to the digital canvas. For example, for my private illustrations I usually work on between one and three layers all the time, just as I would work with traditional oils on canvas. Unfortunately, the same approach isn't practical when taking on commissions from a client. If, for example, they decide to change a gun design but your gun isn't on a separate layer, then you'll spend a lot of time tweaking the design, compared to the time required if it's on its own layer, with textures and shades on separated layers.

Certainly in the case of commercial illustration it'll benefit you to know and understand the capabilities of the tools you use, and how you can get the most from them. In this workshop I'm going to be showing you my way of painting an illustration as if it were a 3D model, complete with its own materials, textures, light and effect layers. This will enable you to change any element without too much trouble. I'll help you to concentrate on the painting process to create all elements of the illustration at the same time, so you can show your piece to the client at any stage and it'll still look like a complete painting.

1 **Submit sketches for approval**
After I get a brief (a quizzical take on Jennifer Lawrence a la Hunger Games) and searching the web for references, I start with four rough sketches. I try to make them different from each other not only in composition or camera angle, but also emotionally: here are willingness, confidence, playfulness, dedication, so the client can choose what he likes the most.

2 **Polishing shapes and anatomy**
After the client chooses one version, I transfer the sketch to full-screen, reduce its Opacity to 16 percent and redraw it on a separate layer. I start with central and constructional lines this time, so that shapes and anatomy will be more precise. This phase is still rather rough, but I prefer to detail on the last stages, starting from the large-scale and ending with small.

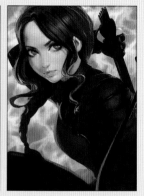

3 Separating materials
I start to block separate materials on separate layers, so that later I can easily work on one element at a time, and hide areas using masks. Then I set my sketch layer's blending mode to Color Burn, duplicate it and add a Blur Filter (10 percent or so). This makes the colors of sketch lines much closer to the colors of materials, and the blurring adds a soft shadow effect.

4 Color Burn for shadows
I group all of my character layers and create a new Color Burn layer clipped to the character layers group. I start to paint shadows with my elliptical brush and Airbrush with light gray colors – this is going to be the base of character's shades. So, the normal colors I blocked in step 3 are the midtones, and this clipped Color Burn layer is the shadows.

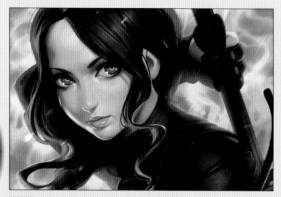
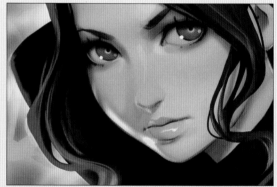

5 Tackling the details
I start to add more details and depth to the character by creating new clipped layers on top of the character group and new layers clipped to the material layers. In this way, when working with layers clipped to the group I add more volume, and when working with material layers I add more texture. I switch between them to progress with all the picture at the same time.

6 A fiery backlight
I add a new layer clipped to the character in Color Dodge mode this time, and fill it with black – when you use brushes with Pressure Opacity, this makes them look much better. I now add a backlight from the background fire with my usual airbrush and elliptical brushes, using a grayish orange color. I also use Color Dodge layers for highlights and the catchlights in the eyes.

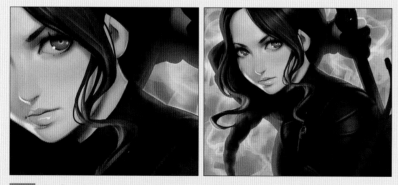

7 Soft glow and refined shadows
It's Lighten and Darken time! Using layers set to Lighten mode I create a soft glow from the fire on the character's edges, and Darken is especially convenient when you need to add more shades to your shadows but don't want these to affect your darkest shadows, like those on the hand and neck here. What can I say – blending modes are of real help when you want to speed up your painting process!.

8 Introducing more details
For me, detailing is the most enjoyable part of working on an illustration. Adding more shadows, texture and volume to the base is very satisfying, but it's important to not get carried away and always think of the illustration as a whole. I add some make-up, casting shadows from the hair on the face, and more hair details. I also spend some time on the badge.

9 Texture brushes

Now it's time to make the armor feel more real. I have a lot of standard texture brushes and free brushes you can download with a lot of textures, shape variations, and so on. Finding a brush that suits your demands is pretty fun too! The detailing is 90 percent completed, and we can now work with effects, which is my favorite part of the job!

10 Light my fire!

Using separate Color Dodge layers filled with black, I add more light to highlights and to the fire at the bottom of the piece. I also add some sparks, which helps to create a feeling of motion and the impression of a strong wind. I also add an Outer Glow effect to the sparks and fire layers. Now the illustration is starting to look more like I imagined it would!

SHORTCUTS

HUE/SATURATION
Cmd+Opt+U (Mac)
Ctrl+Alt+U (PC)
Quickly adjust your layers' color and darkness with this useful tool!

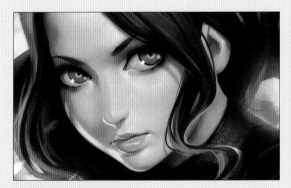

11 Apply motion blur

Now I create a flattened copy of all the layers at the top of the layer stack (Cmd+Opt+Shift+E or Ctrl+Alt+Shift+E) and add a Motion Blur effect to the new layer. Using a layer mask, I hide the effect in areas that I don't want to be blurred: the face, hair, armor and other focal points. Here it helps to create a stronger feel of heat from the fire, especially on the edges of the body.

12 Make use of a photo texture

I have a lot of photos of random textures I've taken out on the streets, so here I decided to use a photo of the texture of a Japanese concrete lamp post to add a more grainy and random feel to the illustration. I set the Opacity of the photo layer to 35 percent and change its blending mode to Soft Light. I also adjust the Hue of the photo using Hue/Saturation.

RESOURCES

Custom Brushes
ELLIPTICAL

A standard brush, very handy for sculpting big shapes. I also use it for the sketching stage.

AIRBRUSH

This brush has a nice grainy texture, so it's really good for creating soft glows and gradient shadows.

SPARKS

I often use this for sparks effects, and also for an impression of wind.

SMOKE

This one is really good for smoke and fire effects; I also use it a lot for floating ribbons.

13 Unsharp Mask

Next I use the Unsharp Mask filter (Filter > Sharpen > Unsharp Mask) and Noise filter (Filter > Noise > Add Noise) to emphasize the graininess and create the feeling of photo taken in a fire. At this stage you could say the illustration is complete, but I love to add one little, tiny step: chromatic aberration, which helps to create even more of a film feel – see the box on the facing page.

14 Finishing up

Finally, I check for mistakes by flipping the image (Image > Image Rotation > Flip Canvas Horizontal). If everything is okay, I flip it back and save! This process is different from what I use for private illustrations – it's a little bit slower – but with this you can go back to every last step by just turning off the layers, so it's easy to make changes and at practically no risk, too. ■

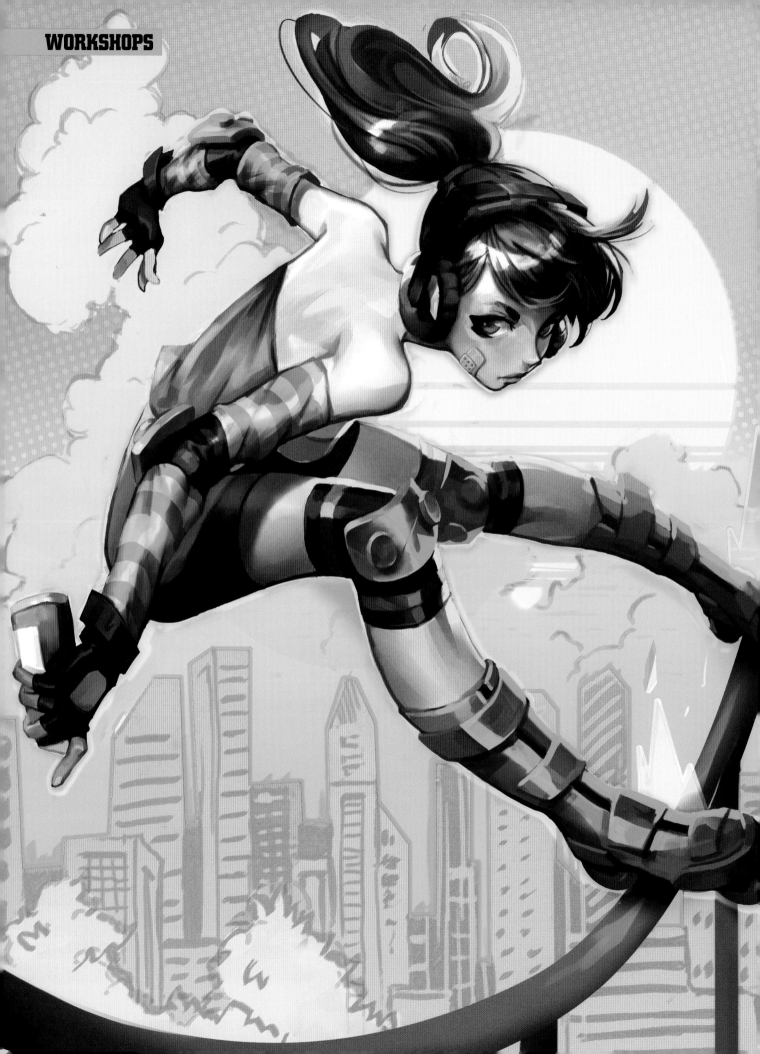

PHOTOSHOP

LEARN NEW MANGA COLORING SKILLS

JAMES GHIO breaks down his rendering techniques for creating colorful and appealing manga art without having to render every element

ARTIST
PROFILE

JAMES GHIO
LOCATION: Canada

Cover and concept artist James has worked for companies such as Udon, Capcom, Marvel, Bandai, and Microsoft Studios. He's currently taking a break from the industry and is busy developing a self-published project.
http://ifxm.ag/j-ghio

GET YOUR RESOURCES
See page 146 now!

ImagineFX
VIDEO WORKSHOP

PRO SECRETS

Painting is all about drawing
Drawing is more important than painting. You'll never be able to improve a bad drawing by adding color, so it's crucial you ensure that your drawing and forms are clear before you begin adding color.

In this workshop, I'll explain the basic rendering techniques that artists can use to effectively manage their illustration process.

There's a primary directional light in my painting that helps show off forms with a strong degree of clarity. I'll be explaining the significance of this lighting scheme and how to render out the lights and darks within a set tonal range. Note that I'll be keeping all the tones within this tonal range until I'm satisfied with their overall forms. After establishing a strong black and white base, I'll apply color through the use of Color adjustment layers.

As you decide on your tonal range, think of it as 0 being white and 100 being black.

When working in black and white, it's best to keep the tonal range close and maintain the values within 30 units of each other. This means that when rendering, your lightest tone should be only 30 units brighter than your darkest tone.

Once you've finished this tonally controlled rendering, you can add tones outside of this range to enhance your core shadows, drop shadows and occlusions in the dark areas, as well as any highlights or speculars in the light areas. I'll also discuss color choices and how these decisions reduce the time taken to finish the image. Finally, cover and box art require some design flair in placing elements to strengthen the composition, and so I'll reveal how you can achieve this.

1 Start off by being messy
Here's the preliminary gesture for the final image. This is the stage in the process in which you can be as gestural as you want to be. Go ahead and be messy, use construction lines and energetic lines until you find the pose that you're looking for. Sometimes you'll find new and interesting ways of constructing a scene through these unplanned lines.

WORKSHOPS

PRO SECRETS
Work smarter in grayscale
Keep your grayscale forms simple. Some forms aren't shown through tones – they're simply indicated through shifts in color. Hue transitions can trick the eye into seeing forms that aren't grayscale. Depending on the material, you may need to use several layer styles to achieve the color and contrast you want. For example, use an Overlay layer to increase contrast, or a Color layer style to preserve existing contrast in the scene.

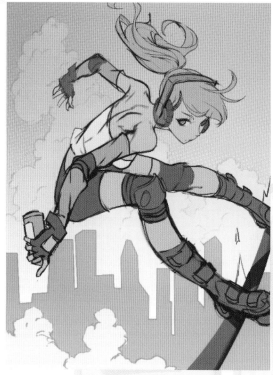

2 Ask around for help
Manga styles do not come easily with me. I usually have to render the image out to achieve the details I'm after. But there is a shortcut that I've found to be useful… ask another artist friend for help! In this case, my wife helps me draw out the hair and eyes, which comes naturally for her because she's a manga artist by trade.

3 Smoothing out the structures
I always draw plenty of anatomy details during the initial sketch stage. Even though they'll probably fade away during the rendering stages, such subtle details will still leave an impression. As you can see in the character's back, most of the lines are now rendered out. Accurate, low-key anatomy will set your art apart from the crowd.

RESOURCES
Workshop Brushes
Photoshop custom brushes:
SQUARE

The square bush is for solid forms and I use it for sharpening edges.

RENDER

This brush helps me draw and render without having to switch brushes.

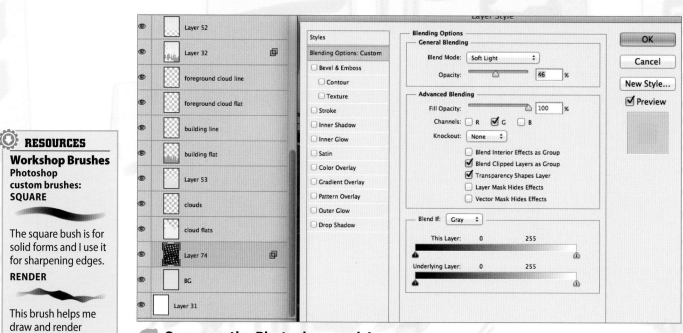

4 Summon the Photoshop gods!
I want the background to pop and feel real, even though it'll eventually have a two-dimensional, stylized look. So I begin messing with Photoshop's blending options, filters and inverted controls. While doing this, I never know where it's going to end up, but eventually something magical happens as I keep applying layer effects.

Fore-, mid- and background considerations

I become aware that something is lacking in the composition. I had initially used the clouds as a filler in the lower left-hand side of the painting. One of the requests from the ImagineFX team was to ensure that there was no drastic foreshortening coming from the character's pose. So, bearing this in mind, I need to find another element to work as a foreground component. Moving the rail into view is a good solution.

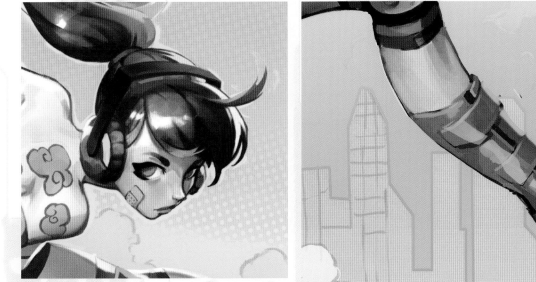

Video game style influences

All the colors are laid out, which gives me a great opportunity to start transforming features and details. Another request from ImagineFX was to have a Jet Set Radio-like underlying theme. So I render out the face with similarities from the game's unique style while trying to maintain a manga likeness at the same time.

Making elements shine

For my final highlights pass, I use a separate Overlay or Color Dodge layer and draw out a thick highlight with Transparency turned on. Then I use an eraser to create the highlight shape. It's similar to masking but a little more intuitive, and because it's on a separate layer you can adjust the color with the Hue slider.

PRO SECRETS
Create precise brush strokes
During any stage in the painting process, keep your brush opaque to avoid pushing paint. A soft brush will force you to render endlessly. Using an opaque brush will establishing clearer and precise marks. It'll also help prevent muddy color transitions and overly rendered forms.

8 Add color to those highlights
It's important to separate lights by color. Here, the red circles are the primary warm highlights. Notice how the highlights are almost purely white. The blue circles are areas that take on the yellow light from the background. This helps the viewer easily distinguish between the different lights being used. Essentially, it's directional light versus rim light. I use a Darken layer for this process.

9 Build up a scene around a hue gradient
Here, I've broken down the background into a color gradient so you can see how there's a smooth transition of color despite having contrasting elements, such as the buildings against the clouds. In everything you paint, you should be looking for ways to implement color gradients. Think of the whole image as one big abstraction of color, and then find ways to bring certain areas of color together.

10 Make it glow
Of course, with every splash of color you need an element of glow. Using an Exclusion layer, I remove the green channel so that I can have a green knockout glow effect behind the character. It helps lift the main character off the background, as well as pop her off the page.

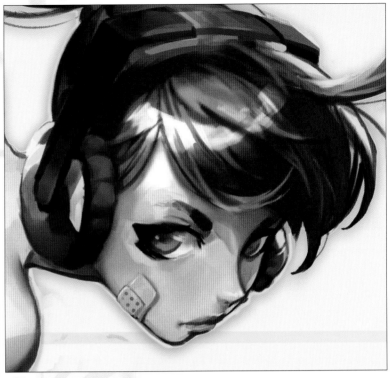

11 Checking your tones

At this point I need to check the tones within the composition to make sure that I haven't pushed the contrast too far. I strongly believe you should be constantly toggling between color and grayscale views throughout the entire painting process. To do this, select View>Proof Setup>Custom… and apply the settings that are shown above. Now every time you press Y you can see your work-in-progress as a grayscale image.

12 Application of detail

Although I'm keeping this illustration pretty simple, it never hurts to carry on detailing (at least, up to a point). I prefer to detail using highlights.

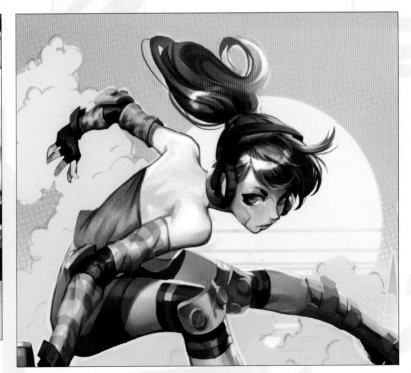

13 Correcting uneven tones

To connect the character to the background's overall palette, I change her shirt to a deep orange. Even though it's tonally correct, her shirt was blending with the background clouds too much. It's never too late to make these kinds of adjustments. Don't settle for what you've painted until your eyes agree with the overall image!

14 Showing your reasoning

I realize I need to justify why there's rim light on the character. Art doesn't always need to make sense, but in this case the colorful environment means I definitely need to show the cause behind the effect. What better way to do this than by painting a giant stylized sun to match the rest of the background? ●

PHOTOSHOP

GENERATE VOLUME AND DEPTH EASILY

SVETLANA TIGAI renders a semi-realiztic portrait using light and shadows to develop volume and depth, before making the move to color

ARTIST PROFILE

SVETLANA TIGAI
LOCATION: Kyrgyzstan
Svetlana is a freelance artist who works in book and game illustration. She spends her free time developing personal projects.
artstation.com/tsvetka

Sometimes I paint in black-and-white. It's a great chance to work with light and shadow, and is a good technique for learner digital artists to grasp, as they practise depicting volume and depth using only shades of gray.

Before I start drawing, I think not only about the composition, but also about the setting. Beautiful portraits are improved if they have a story behind them. I want to make sense to all of my pictures. That's the way

I express myself – the way that I communicate with my audience.

It's not easy to tell a story without a detailed background. I like to draw portraits with the hands, because hands, like the eyes, can also speak. So if you want to draw an interesting portrait, don't ignore important things such as the pose. The color palette also plays an important role, because it creates the atmosphere of the painting; it emphasizes and enhances the mood. For example, blue doesn't always

mean a cold or sad mood, yellow doesn't always mean joy and fun. In the context of a story, sometimes a warm palette can add a sense of mystery.

In this workshop I'll draw a pale girl with very blonde hair in a white dress on a light background, and I'm going to show you how to achieve volume at low contrast. We'll end up with a very gentle and rather mysterious effect. I'll also show you how to color a black-and-white picture using gradient maps.

GET YOUR RESOURCES SEE PAGE 146

ARTIST INSIGHT
Use Camera Raw filters
This filter, present in Photoshop CC, isn't only for photographers. Go to Filters > Camera Raw filter and play with the temperature, tint and vibrance. Sometimes you need a fresh view on your picture, and by using this filter you can develop interesting color schemes for your composition.

1 Laying down the initial sketch
It's important not to use pure black or white, because this may distort the perception of depth and volume. After all, black shadows don't exist in real life. With this in mind, I change the color of the background from white to gray, then create a new layer for sketching and use a dark gray. This produces a very low contrast, making it easier to visualize my idea.

2 Establishing the light source
I need to determine the light source early on in my painting process, so I use a large soft brush to identify the main spots of light and shadow. Then I take a hard brush and paint in some drop shadows. At this stage there's no need to detail individual elements of the image.

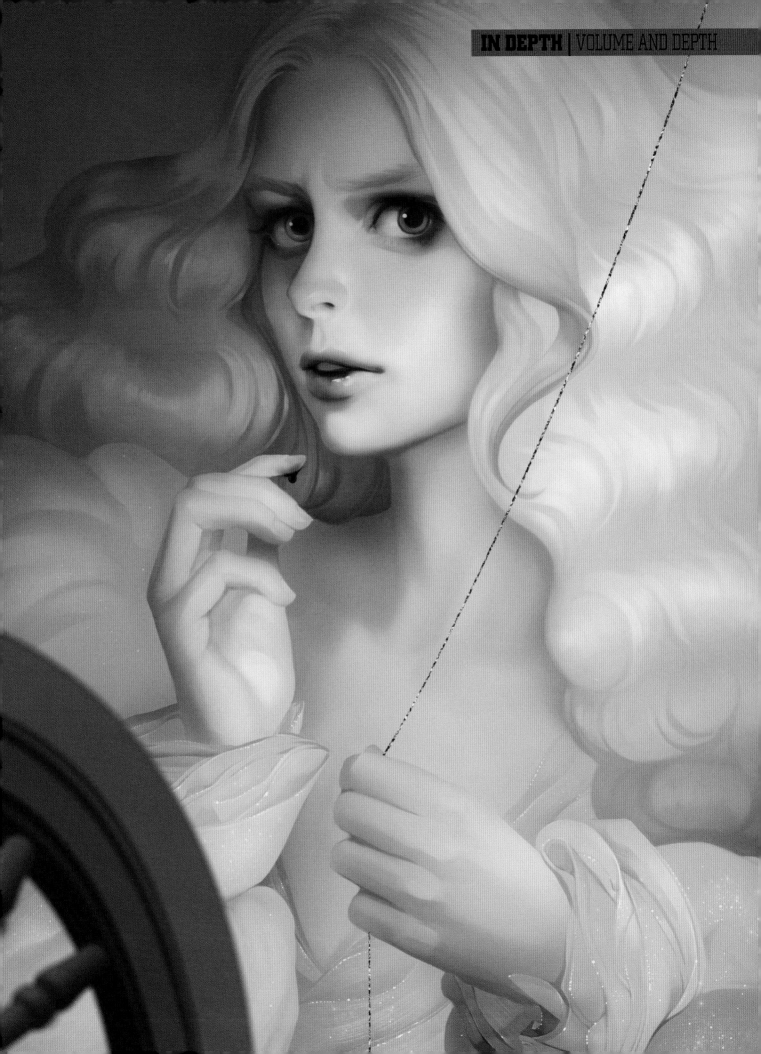

3 Refining the edges
Once I've decided on a light source and a main volume, I move on to enhancing the depth. I separate elements, using a soft brush to apply a little shadow on the edge. Then with a hard brush I remove excess touches. The Lasso tool can also be helpful for emphasizing edges.

4 Detailing my character's face
To make eyebrows or eyelashes look more natural I don't waste time drawing each separate hair. Instead, I draw a shadow cast by the eyebrows along with the lit skin that can be seen through the eyebrows. I also use this same principle when drawing eyelashes and hair on the head.

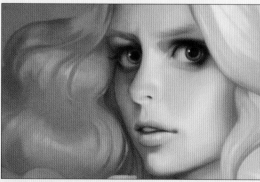

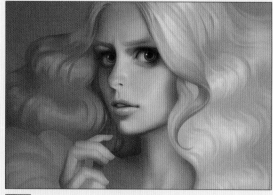

5 Shadows and soft fabrics
First I draw a shadow, and only then paint what casts the shadow. This means that I don't need to create countless layers. I prefer to work on three or four. If in doubt, I draw a new element on a separate layer. If I like the result then I merge all my layers. It's also important that I accurately depict the texture of the sleeve fabric. First I make a multi-layer chiffon neckline and then repeat this for the cuffs, so they look like the petals of a rose. To give tissue more luster and texture, I use a custom brush and apply a few scratches.

6 Painting curly hair
To create the effect of soft, silky, bouncy curls, I avoid creating a strong contrast between shades of gray. To focus the viewer's eye on the face, it's not necessary to detail all the strands, perhaps just those located near the forehead and cheeks. I also avoid custom brushes for painting hair, because they can easily create the effect of a fabric thread rather than strands of hair.

7 Making the most of Gradient Maps
Gradient Maps is a wonderful tool for coloring-in black-and-white drawings. You can manually set any color for each shade of gray. Click the black-and-white circle icon at the bottom of the Layers tab, then select Gradient Maps. Don't forget to click the icon that clips the map to the layer with your painting on it.

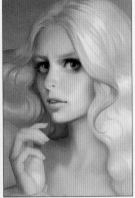
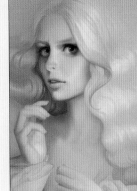

SHORTCUTS

MERGE LAYERS
Cmd+Shift+E (Mac)
Ctrl+Shift+E (PC)
Keep things organized by quickly merging all existing layers into one new layer.

8 Adding more color

I create a new layer in Soft Light mode and add a little paint to my pale girl. Even if you paint with vivid colors, on a Soft Light layer they work perfectly and help produce a soft tone. For my subtle palette there's no need for overly saturated colors. Bright colors will distract the viewer's attention.

9 Take into account ambient light

Sometimes, to emphasize a warm palette, I add some cold colors on to the periphery of the painting. I start by creating a new layer in Color mode. Remember that Color mode transmits strong saturation, so to avoid a vivid blue, I choose gray. You look at the picture and think it's blue, but in reality it's not. On yellow, gray works as a blue. Try it for yourself!

⚙ **RESOURCES**

Custom Brushes
SUPER SOFT ROUND BRUSH

I use this brush to establish a soft transition between colors.

SOFT ROUND BRUSH

This brush isn't really soft, but it's not firm either. I draw everything with it.

SCRATCHES

This is the texture brush that I usually use for drawing chiffon fabric.

You can draw dirt with this brush, but I prefer to use it for gold sparkles.

10 Drawing and painting the spinning wheel

I create the wheel on a new layer. Using the Pen tool, I draw a clear arc, then duplicate it several times and shift every new layer down. I also draw a spoke and duplicate it three times. Then merge all the layers and apply Filter > Blur > Lens Blur.

11 Creating a sparkling texture

On a new layer I draw a black line as the thread. I select Pattern Overlay mode in the Layer Style dialog and choose my golden sparkles pattern. To make a pattern like this you need to open a new file with a picture of a sparkling surface, then go to Edit > Define pattern and click OK. The texture will then appear in the pattern list.

12 Applying the final touches

I'm nearly finished – I just need to add the final touches such as extra lights and glare. I draw shimmer on the fabrics using a standard hard Round brush. I also add a drop of blood on the finger, which my beautiful needlewoman accidently pricked. A barely noticeable mark of blood on her lips adds some mystery. At the end, I play with the Levels a bit, but not too much, because that can lead an excess of contrast. You can also adjust the Saturation and colors, if needed. And that's it! I hope you liked my workshop and found it useful. ∎

ARTIST INSIGHT

15 SECRETS TO GET BETTER AT MANGA

Veteran of the UK manga scene **SONIA LEONG** gives key advice to artists wanting to draw and paint authentic-looking manga…

ARTIST PROFILE

SONIA LEONG

LOCATION: England
Sonia has illustrated for SelfMadeHero, VIZ, Titan Comics, Image, Toyota and many more across different industries. She loves fashion, food and playing video games.
www.fyredrake.net

While the style and finish of manga is relatively minimalist in comparison to other types of comics, this apparent simplicity is deceptive.

Every line is a choice made by the artist. The thinking is never use ten strokes to depict something if just a single, well-placed one would suffice.

This principle of concentrating on what's needed to relate a story permeates throughout manga creation. Every panel is an exercise in choice: size, zoom, camera angle, speech bubble positioning, and type of background. Every page works as a whole to control the reader's experience, particularly in pacing.

Production is geared towards minimizing costs to maximise number of pages, so most manga is in cheap black and white.

This has led to the development of specialist techniques to add depth and understanding and to enhance both action and emotion. Stretching limbs, blurry lines and irregular panels add dynamism.

Extreme close-ups, abstract backgrounds and symbolizm add intensity and atmosphere.

We're not afraid to steer away from realizm if it helps to convey meaning more effectively. It's not just about how you draw the characters, it's how you tell the story.

1 Scripting and Panel Count

When you're writing for manga, remember it flows faster and sparser than other types of comics. It spreads across more pages with fewer panels per page. There is variation between the types of manga; Seinen manga, aimed at adult males, will be more densely packed than Shoujo manga, which is read by young girls. But as a guide, aim for a maximum of three speech bubbles per panel, an average of five panels per page, and around four pages per scene.

2 Reading direction and rules

Manga originates from Japan, and Japanese traditionally reads vertically from top-to-bottom before going right-to-left. So for any manga originally published in Japanese, you start reading from the top right corner and finish in the bottom left. If it's been translated into English, you'll often find it remains this way. But if you're writing in English from the start, there's no need to do this, so it's up to you! Decide on your reading direction and stick to it.

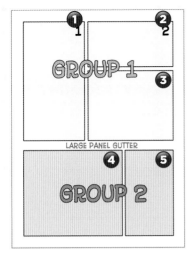

LARGE PANEL GUTTER

3 Grouping Panels

Most manga have panels of different sizes and shapes that change from page to page. There are no arrows or numbering to guide the reader, so you must group the panels clearly to make it obvious they must read one bunch of panels before moving on. Separate one group from another by increasing the space between the panels (the panel gutter). Then make sure that any small panel gutters inside a group don't line up with any panel gutters in another group.

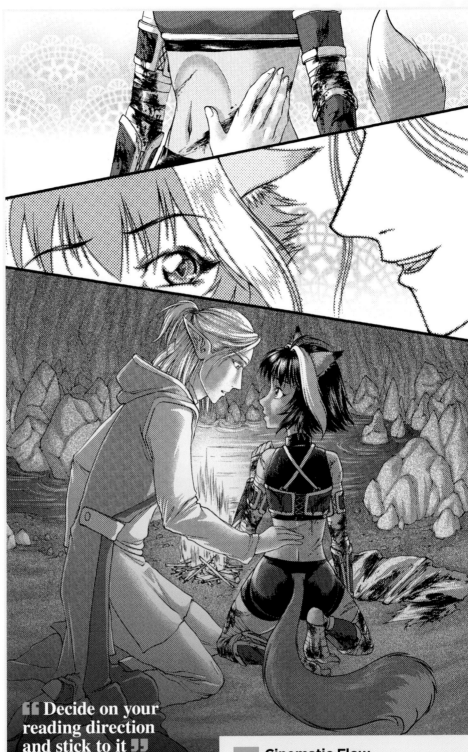

"Decide on your reading direction and stick to it"

4 Abstract Layouts

Manga doesn't just stick to traditional boxes in rows. It often employs dynamic panel layouts that stretch across the height or width of the whole page, along with diagonal lines and irregular shapes. Sometimes boxes aren't even used at all, with hazy patterns used as outlines, or the character breaks out of the panel. Panels can even fade in and out as part of the storytelling. The difficulty is ensuring that regardless of layout, the panel order remains clear. Try reading some manga to find lots more examples to play with.

5 Cinematic Flow

Manga is known for its cinematic feel. Every panel is like an action movie, where the camera cuts from a close-up of eyes, to a two-shot profile of a conversation, to a bird's-eye view of the characters, then a low-to-high angle as a stiletto heel clicks onto the floor. Really make an effort to showcase different camera angles and zooms in your story.

6 Screentone Basics

Manga uses screentone as its black and white. Simply paste it on top of your lines and then cut away the excess.

A Scan in your line art

Prepare your line art. It has to be in pure black and white without any grays, so scan at a minimum of 600dpi. Then threshold-to-convert every pixel into either black or white. The same must apply to your desired screentone: each pixel must be black or white/transparent.

B Apply the screentone

Copy then paste the screentone on a layer above the line art, enough to cover the lines and more. If your screentone isn't transparent, for example, on a white background, then set the layer to Multiply so you can see the lines underneath.

C Edit back the screentone

Remove unwanted areas of the screentone. There are many ways to do this: you can select with a Lasso/Magic Wand tool and cut, use the Eraser in Pencil mode, or use a Layer Mask with a hard-edged brush so that no grays are introduced.

> **Manga speech bubbles are taller than in Western comics. They also have lots of space around the lettering**

7 Speech Bubble Basics

Japanese people traditionally read top-to-bottom and then right-to-left. To accommodate this, manga speech bubbles are much taller than in Western comics. They're also roomy, with lots of space around the lettering. Another key feature are tails denoting the speaker are either very small or non-existent. Rather than relying on tails, the speech bubbles are positioned near the speaker's head – use those camera angles wisely! Japanese dialogue also tends to makes it clear who's speaking, due to special verb endings and slang.

8 Speech Bubble Styling

Speech bubbles in manga are a lot more organic than in other types of comics. They're almost always hand drawn, slightly irregular in shape. Joined speech bubbles are combined rather than linked by a thin line. When one character talks over another, it's depicted literally, with each speech bubble overlapping. While shouting is depicted with a more conventional spiky outline, thought bubbles aren't drawn as clouds; more often they're surrounded by a haze, either drawn or made out of screen tone.

9 Sound Effects

Japanese sound effects are incredibly diverse, using all manner of consonant and vowel combinations to describe crashes, thumps and slices. Pronunciations often more realiztic than in English like "roar" (GA-O-!) or "slam" (pa-tan!). What's unique to Japanese onomatopoeia are sound effects for abstract concepts ("shiiin" for a stare, or silence), facial expressions ("niko" for a smile) or even temperature ("poka poka" for warmth). They are an integral part of the artwork, so are hand drawn at the point of inking, in an appropriate style.

10 All Things Chibi

A chibi is a cute, squishy, mini-version of a person, squished down to just three to four head lengths tall, with a large head and a chubby body. Shoulders are rounded off, hips are wider, hands and feet become stubby. Although these characteristics are childlike, remember that you're not actually drawing a child! An adult chibi should still look like an adult, just highly stylized. In manga, characters are often portrayed as chibis when the story takes a lighthearted turn, for comic effect. Spot all the examples throughout this article!

12 Visual Grammar

Many symbols are used in comics to enhance the viewer's understanding of what the characters are feeling, like punctuation marks for pictures. Perhaps a love heart to show romantic intentions, or a light bulb when someone has a bright idea. Manga has some unique examples: a sweatdrop for nervousness or embarrassment, a hash mark for raised veins on the forehead when someone is angry, and little spirit wisps gathering when someone is feeling depressed.

11 Anthropomorphism

Another popular technique used in manga is 'kemonomimi', which literally means animal ears. For instance, if someone is being as sly as a cat, you can draw her with feline features; most notably cat ears and a cat tail. You can even go further with cat eyes that have slit-pupils, and using the shape of cat's mouth. Why not draw a disappointed guy as a sad puppy dog? A fierce mother as a dragon? Like chibi, it can be used for effect in specific scenes, but it's also popular as a character design for fantasy stories.

13 Emotive Backgrounds

One key difference between manga and other types of comic is the use of abstract backgrounds to match the atmosphere and the emotions of the characters. Once the scene has had an establishing shot of the physical surroundings, the backgrounds can be anything: lacework and flowers to signify a budding romance; flames if someone is full of burning rage; black shadows and swirling knots to convey inner turmoil; or cookies and cakes when a character is irresistibly cute! This is particularly popular in Shoujo and Josei manga, which is aimed at girls and women.

> " Unlike superhero comics that have fully inked characters, manga favors limbs that blur with motion "

14 Depict Movement

Manga is a dynamic form of storytelling; when a character is in a full-blown fight, they really look like as though they're moving, even flying out of the page. Unlike superhero comics that have fully inked characters and points of impact, manga favors limbs that blur with motion, backgrounds that become speedlines, channeling and enhancing the direction of the motion and highlighting the point of impact with emphasiz lines originating from it. Most of this is done through inking, but can be done with screentone, too.

15 Screentone Effects

There are many things you can do with screentone besides just sticking it down for shading. Add white pencil over both lines and screentone for traditional white painted highlights. Try soft, burnished highlights by using an Eraser set to Dissolve. Use screentone just over the lines to give the art a blurry feeling. You can increase the contrast in your shadows by layering different screentones on top of each other, but be careful: you may get moiré if you use different densities or if you align them incorrectly.

PHOTOSHOP

EXPERIMENT WITH LINE AND COLOR

SAI FOO takes you through his creative process, as he paints a character cheerfully falling from the sky using line art and simple coloring

ARTIST PROFILE

SAI FOO
LOCATION: Malaysia
Sai is an artist based at Streamline Studios in Kuala Lumpur. He previously worked in advertising and animation. In his free time he produces personal art a world away from his day job. http://ifxm.ag/s-foo

GET YOUR RESOURCES SEE PAGE 146

The painting technique that I used for this piece is pretty straightforward, so I'll talk about my ideas and decision-making processes that developed while I was drawing this piece.

I started this image for fun during my free time. I got inspired while randomly watching anime shows one Saturday morning. I wanted to convey a floating or jumping character, on a bookmark-sized canvas. After trying out a variety of poses, I ended up with a female student figure descending from the sky.

The biggest headache during the initial stage was the skirt. I wasn't keen to go down the road of doing what's widely known as a "fan service" piece, so I moved the left knee a little more to the left of shot. My aim was to depict a character loaded with accessories, so I gathered references for a Japanese schoolgirl's bag, and added it to my vague memory of what other items my school friends carried around with them.

In one of my sketches the character is holding on to her umbrella. It looked a little awkward and so I decided to separate the hand and umbrella. The reason for including the umbrella was to have an interesting shadow cast over the character, and to depict the effect this had on colors that were now in the shade. ■

RESOURCES

Custom Brushes
CORE SET

My regular brushes include a lovely one for creating a pencil-like effect – ideal for line art. I use a default brush for fills and touching up, and a Soft brush for gradient effects and erasing.

How I create...
A FALLING FIGURE

1 Capture the best pose
I start off by producing a series of rough sketches that help finalize the composition, character pose and accessories. I create between two and three layers over a sketch before I actually refine my art. I take it slow at this stage so I don't muddy the line art.

2 Layering and cleaning up
I love this stage the most, because it involves fixing every small detail of everything in the image. I also have to decide what elements of the image go on which layers. I'll go back to the refined sketch layer whenever I'm uncertain how I should progress.

3 Coloring and lighting
Right from the start of the process I have a rough idea about the lighting and color I'll be depicting. I prefer to fill in elements using a solid color, so that any future color adjustments will be easy to do later on. I also apply a simple shadow here.

BADGE DESIGN

Here are a couple of badge design that I did for the character's accessories. Most of them are actually just random designs that sprung to mind. I paint them straight on, because it'll be easy for me to skew the perspective later. I'll then merge them with the character's line art layer.

BACKGROUND PATTERNS

For the background pattern, I make vertical lines and distort them with the Transform tool to create the perspective effect. I repeat this procedure and gradually create thinner lines. I select the Smudge tool and drag it across the line to create the wavy lines. Finally, I add a screen dot texture in Overlay mode.

LAYERING AND RENDERING TECHNIQUE

This is the usual setup for my layers. I always use Multiply for shadows, with a mask so I can experiment to find which angle is the best. I use Overlay mode for coloring the inside of the shadow, and Hard light to paint highlights.

LIGHTS EFFECT

For a final touch, I add laser light effects to make the whole image more vibrant. I draw a solid color shape and add an Outer Glow using Layer > Layer Style. Most of my effects work is separated out on different layers, which makes it easy to amend and tweak.

SHARPEN YOUR CARD ART SKILLS

Fantasy card art is all about eye-catching compositions and engaging character designs. **LAURA SAVA** reveals how she achieves this every time

ARTIST PROFILE

LAURA SAVA
LOCATION: Romania
Laura is a freelance artist who creates illustrations for mobile games such as Legend of the Cryptids and Mobius Final Fantasy. artstation.com/laurasava

Even though I started dabbling into fantasy art as a teen, for a long time I never thought of it as any more than a hobby. The first decisive step on the illustration path was getting a Wacom tablet, and switching to digital eventually proved to be a game changer for me, because it solved both the issue of speed and the high cost of art materials.

I attended an art school, but found that the emphasiz was placed exclusively on contemporary trends, so I had to learn most of what I know about figurative painting on my own. However, a formal art education gave me a better perspective on technical matters and perhaps created a framework for an efficient learning approach. So the tips in this workshop are an assorted collection of theoretical principles I

picked up in school, personal observations and advice I found online.

I'm currently illustrating cards for Applibot's Legend of the Cryptids, a fantasy game for smartphones, so I'm going to use images I created for the company to show how I apply this information in practice and, I hope, provide some useful insight for anyone interested in producing similar work.

GET YOUR RESOURCES SEE PAGE 146

ARTIST INSIGHT

Study photos, don't copy

When in doubt, use reference. That doesn't mean copying a photo as it is, but studying one or more images to figure out how something looks or works. If you need to use precise reference, there are plenty of sites with legal free photos – my favorite source is www.morguefile.com.

1 Deciding on the composition

There are basically two types of composition: dynamic and static. The first is characterised by diagonal lines that add movement, while the second features strong verticals and horizontals that either help to create a calm atmosphere if horizontals predominate or suggest harshness if the verticals are emphasised. I prefer static compositions, but they can be a bit dull for fantasy themes. As a compromise, I use softer diagonal shapes as accents in the foreground. For example, placing objects such as flowing fabric here and there helps to break up the monotony and develops a pleasing contrast with the background.

2 When to use symmetry

There's a time and a place to use bilaterally symmetrical layouts. Indeed, I'd go so far as to say that this type of composition should be used sparingly, but it's certainly effective in appropriate contexts. Its visual impact is high because all lines converge and the eye is drawn towards the center, so illustrated subject matter such as book covers or film posters can benefit from it. Symmetrical poses can make a character look regal, powerful or heroic. They usually work especially well with characters who have wings and mythological beings in general, because they remind the viewer of iconic representations.

3 Apply the S-curve principle

This goes back to ancient Greek art and is considered ideal for depicting the human figure. The body should be positioned in a way that describes an S-shaped line, so that the shoulders and the hips are angled differently. The most basic pose that uses this principle is contrapposto, where the figure rests all its weight on one leg. In illustration, this formula can be taken even further, and curves and proportions can be exaggerated or stylized according to your own painting method.

> **ff** The first thing people notice in a picture is human faces, so they become natural focal points **JJ**

4 Develop focal points

The first thing people notice in a picture is human faces, so they become natural focal points and should, as such, be placed carefully. There are several ways to accentuate them or shift the interest towards other areas of the image. One is manipulating light, such as keeping most of the image relatively equally lit and have strong light hit the area we want to stand out. Variation in brush strokes or colors can also be used, rendering the focal point and keeping the rest of the image rougher and more desaturated.

6 Framing techniques

Depending on the purpose of an illustration, some limitations can come into play, and one of them is framing. My card art is viewed on smartphones, so the characters need to be large enough to discern details and this means sometimes they won't fit into the frame. There are a few rules of thumb on how to crop figures: don't cut where there are any joints, never cut through the hands (they should be either visible or out of the picture) and, for portraits, avoid cropping the ears or chin.

5 Dramatic light

Interesting lighting can quickly give an image a fantasy look. One of the most commonly used – and my go-to lighting scheme – comprises a main softer light and a harsher back light. This combination is even more striking if the light sources have complementary colors, but this can soon become cheesy if overused! Another of my favorite set-ups is a single light source filtered through a window, placed at an angle that suggests the late afternoon sunlight.

7 Detail placement

People organize visual elements in categories and group them into larger shapes, based on their proximity to each other. The Gestalt theory of visual perception has derived a series of rules from this premise. An open area or a barely suggested object will be "autocompleted" by the viewer, as long as its shape is recognized as a whole. This is why it's not necessary to polish every detail or worry about perfect edges – just ensure that the main shape is readable from a distance.

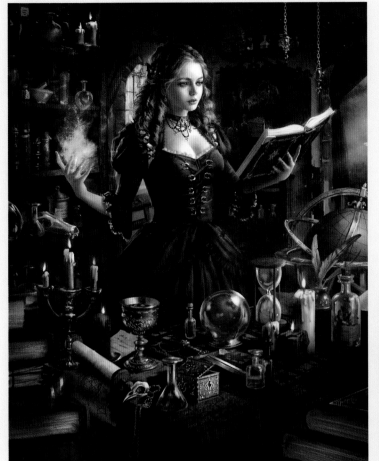

8 Make more of the background

In game cards the focus is obviously on the character, but backgrounds and other details add a whole new dimension. You can hint at a character's personality through their environment or describe their social status or occupation with various nearby objects. A scholarly character could be surrounded by old tomes and scrolls, a warrior will look more menacing with a stormy sky as a backdrop, and a character could be recognized as a witch even without stereotypical costumes, if you simply decorate her place with alchemical paraphernalia and other mysterious-looking items.

RESOURCES

Custom Brushes

RENDER

To sketch and render most surfaces I use a simple hard-edged Round brush.

RENDER_SOFT

I blend skin with an Airbrush. Unlike others, I don't mind the plastic look that it can produce.

OIL PASTEL LARGE 9

The default Chalk brush is especially useful in Color Dodge mode to create metal textures.

LACE

This is a lace brush that I use on fabric, wherever I notice that a costume needs "something extra".

BRINGING EVERYTHING TOGETHER

Discover how Laura developed the character of Anneli, Beguiled Demon, from Legend of the Cryptids

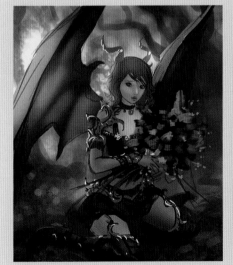

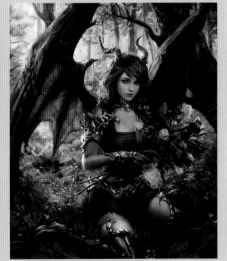

1 Capturing the basic pose

In general, I don't make very detailed sketches; instead, they're rather cartoony. I change my mind a lot during the painting process and resize things or move them around, so precise linework isn't for me. At this point I only care about finding a basic pose and blocking in some shapes and colors.

2 Detailing the face

Ideally, one should work on all aspects of an image at the same time, but I often get carried away working on some element of a piece and forget to look elsewhere, so parts of the image are always more polished than others. Almost invariably, I start with the face and don't move on until it's almost completely done.

3 Polishing the scene

After completing the character, the background is the last element to be tackled, but I make sure it's at least partially rendered first, to avoid discordance. Finishing touches are applied using adjustment layers, usually for improved contrast or color balance. Overlay layers add depth and subtle details, such as dust particles.

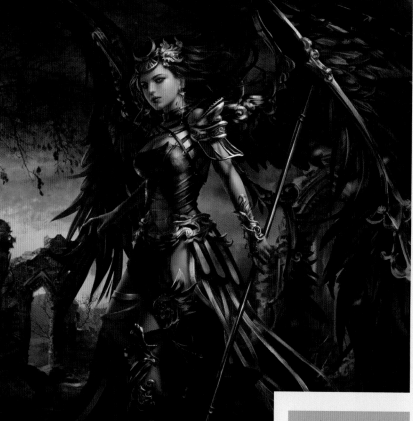

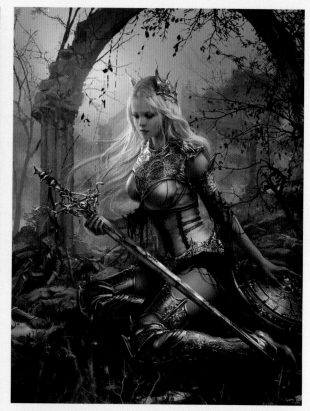

9 Costume design

The greatest challenge I face when designing game cards is coming up with fresh ideas for costumes, weapons and accessories. I follow various fashion, history and culture-related sites and blogs, and I save the most interesting clothing and armor designs in an inspiration folder. I occasionally use an app called Alchemy, which generates unpredictable brush strokes and random shapes, and then I try to find patterns in the resulting image. Costumes can become quite detailed, so to prevent them from looking too monotonous and "crowded", details should be grouped and placed in only a few key places.

ARTIST INSIGHT

Take more photographs

Practice is essential in advancing your skills, but there are a few additional techniques that can be employed for the purpose of building a visual library. Taking photos will teach you to observe things more attentively, it will improve your composition and it will give you a better understanding of light.

10 Giving metal an interesting look

Fantasy art draws inspiration from historical sources, so ornate armor and weapons are commonplace. When dealing with metal objects, I often block in solid shapes and use the Bevel and Emboss option (Layer > Layer Styles). This is only to create a quick base to work with and shouldn't be used as a standalone technique (except perhaps for very small details), because it'll produce an artificial-looking result. As a final touch, I add a few highlights using a textured brush that's set to Color Dodge mode.

11 Advice for painting skin

Subtle color variation is crucial for illustrating realiztic skin, but it can also take a while to blend convincingly. To save time, I've reduced this principle to alternating between the cold and warm hues that correspond to value zones: if light is warm, then shaded portions are cold and darkest shadows warm again, and vice versa. The transition line between light and shadow should be slightly more saturated. Skin is slightly translucent, and so bright light will shine through it, especially in areas with prominent bones and/or less muscle, such as the cheeks or fingers.

> **Clashing elements that work unexpectedly well together are definitely good for fantasy designs**

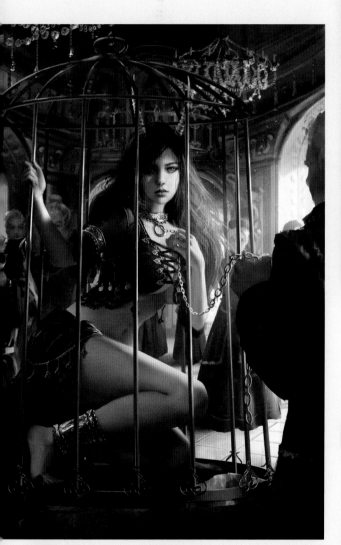

12 Color considerations

In theory, it seems simple to pick a color scheme according to the established art theory rules, but achieving realiztic results involves more effort than that. You have to keep in mind that an object's color isn't so much determined by the way it's pigmented but decided more by its environment – direct and reflected light, weather, time of the day and so on. That said, values are even more important: do them right and you can get away with less-than-perfect-hues. Complementaries are my customary color scheme, with the warmer color as an accent.

13 Beyond fantasy

There's no need to limit your concepts to dogmatic sword-and-sorcery themes; clashing elements that work unexpectedly well together are definitely good for fantasy designs, whether the approach is serious or playful. Besides the obvious cross-pollination between fantasy and sci-fi art, other types of imagery, ranging from Renaissance art to clean 3D looks, can be incorporated into your illustrations to varying degrees. Steampunk aesthetics are known to behave well in the mix, and classical pin-up styles are a perfect way to spice up a card character. ■

SIMPLY PAINT A GRIMM FAIRY TALE

MIN YUM says planning ahead, keeping things simple and having fun are all key to creating a compelling Brothers Grimm fairy tale illustration

ARTIST PROFILE

MIN YUM
LOCATION: South Korea
Min is a freelance concept artist and illustrator from Sydney, Australia. He's worked in films and games for 10 years and currently teaches at Arteum in Seoul, South Korea.
artstation.com/minyum

GET YOUR RESOURCES SEE PAGE 146

Creating a picture isn't easy. There are so many things to consider: ideas, composition, storytelling, mood, color and rendering, to name but a few. It can easily become overwhelming.

At least in this case I have the Brothers Grimm stories to take inspiration from. The editor asks me to paint a scene from a fairy tale, and I choose The Six Swans, in which six brothers have to be released from their avian curse by their sister.

I don't have a set painting process, but I do follow a few guidelines. First, I plan ahead, and that means lots of research. Often there are going to be elements I'm not familiar with, and that means lots of sketching. I'd rather solve any problems at the start than leave them for the final stages. Furthermore, if it doesn't work as a sketch then it's not going to work as a detailed color piece.

Second is keeping it simple – design, color, story… nice and simple! I often have to remind myself of this because it's probably the hardest one to stick to.

Finally, the great thing about digital media is how it's so forgiving of mistakes. So take advantage of it. When I get stuck I'll just go back and take a different route.

Oh, and have fun! This workshop is an opportunity to show a different side of fairy tales. There's something very dry, melancholy yet romantic about them. And it's these qualities that make them such an enjoyable subject to paint.

ARTIST INSIGHT

Give layers colored labels
Layers can easily stack up and are often hard to track. I like to give them a color label, where the eye icon is on the Layers panel, so I know which are important. Right-click the eye icon in the Layers panel and choose a color from the sub-menu.

1 Sketch out your ideas
Every picture should start with a batch of sketches. It's the part where there's very little restriction and more free rein. For me this stage is very simple: I test out composition and design before things start to get heavy. If I can't work it out now then it won't work later. I try to keep it minimal and rhythmic, and sketch only the important elements.

2 More basic color sketches
These are color explorations, done prior to this version to test out how to develop from the sketches. I find things can get very different in color, as opposed to just lines, and these help for previewing. But they're fun too. I've gone with the direction of the first version, but the large moon feels too obvious and may not enable me to try softer colors. So bye bye moon!

3 Setting up moods

This stage is like keynotes in music: it suggests the overall mood and colors. I usually base my colors off a simple wash to determine the range, as atmosphere has a large impact on colors. I try to assign local colors to the important elements, making sure they have enough contrast to create visual interest. I'm not too concerned with details here. Just shapes and colors.

4 Depicting the girl

Of course, the character is a crucial element of the painting. She's going to tell the story, with a subtle tilt of her head, facial expression and posture. I reference Pre-Raphaelite painters to get the feel right. I don't want any direct lighting on her as it may create too much contrast. I want her to look a little more soft with very rosy cheeks.

5 Shaping the tree

I love drawing and painting trees! There's something about finding a random yet organized rhythm to painting natural objects, and trees are probably a good example of that. The trees must complement the girl, without too much distraction. So I make their vertical flows contrast with the more rounded silhouette of the girl.

6 Adding color

Here I decide to add bursts of color patches to lighten up the background. I can also pick off other details such as silhouettes of the forest and define the location where she stands in the story. I find that a variation of cool colors works best here so that these elements recede into the background.

ARTIST INSIGHT
Dual view
Photoshop enables you to have multiple views of the same image open at one time. I have a main working window zoomed in for the details and another window opened at 25 percent zoomed out, so I can check how each brush stroke affects the overall picture. You can open a duplicate view simply by going to Window > Arrange > New window for… (your file's name).

7 Adjustment layers

A great thing about painting digitally is testing out variations using adjustment layers. This is also good for bringing colors together. I mostly use Hue/Saturation and Color Balance adjustment layers, as they give most variation without affecting the picture too much. Color Balance can easily push a picture towards warm or cold tones, but is better for experimenting.

8 The swans

Swans! I've never painted one before, so I spend a few hours gathering references. I've got six to paint. I only go to rough in the patches of lighter colors that will soon be swans. I also add a bit of warmth towards the bottom of the painting, hoping it might help with shaping out the birds.

SHORTCUTS
DUPLICATE IN PLACE
Cmd+J (Mac)
Ctrl+J (PC)
This floats a selection into a new layer but in the same position you copied it from.

9 Detailing the character

My princess looks a bit short, mostly because I want her to be ankle deep in water initially. But that hasn't really been obvious enough. So to solve this I simply extend her dress and then she won't look too short. I want her gestures and overall look to be sad but calm.

10 Swans again

In the sketch I had the two swans in the foreground, but I realize there's too much white and it draws too much attention away from the princess. I move some of the swans to the back – I only need to suggest them. Even after doing this there's still too much white in the foreground. So I darken it a bit and reduce the contrast.

11 Add water

I know water's going to be tricky. I haven't given much thought to it until now. It's going to be very restricted because most elements are already in place, not to mention the contrast issue from the previous step. I find this stage the most difficult, because it's time to tidy up the loose ends while keeping the rendering consistent. With the water in place, it's almost there.

12 Loose ends – begone!

I'm undecided about the color of the girl's hair – yes, there's always going to be something in a picture that bothers you. The tree also seems too busy and chaotic for no good reason. I go back, to almost the start, to bring back the simpler trees that will hopefully be less distracting. I add a slight glow around the character's head and make some more color adjustments. Then I tidy up and finish. ■

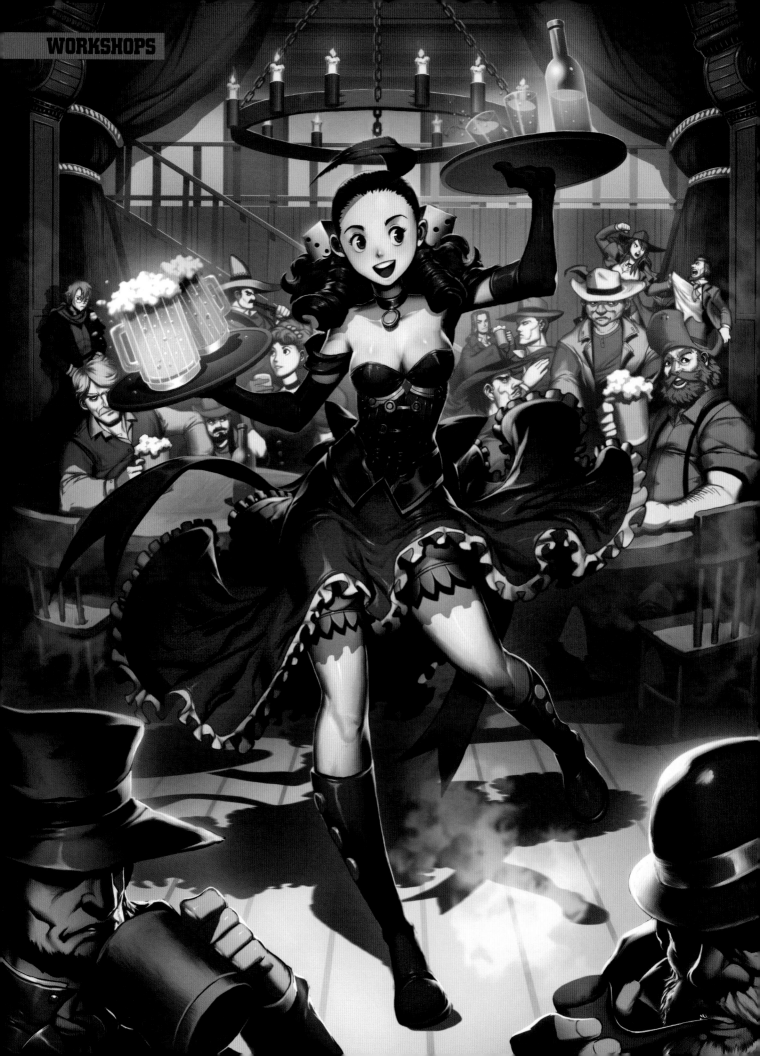

GET YOUR
RESOURCES
SEE PAGE 146

VIDEO
AVAILABLE

PHOTOSHOP

CREATE MANGA WITH A TWIST

GENZOMAN combines two distinct genres to create a dynamic manga composition in a Wild West setting, compete with a bar-room brawl

ARTIST PROFILE

GENZOMAN
COUNTRY: Chile

Genzoman, alias Gonzalo Ordoñez, is an illustrator who's worked in the video game industry, TCGs and comics for over 15 years. deviantart.com/genzoman

Westerns are something I've always loved. In this tutorial I'll create an image in the typical manga style but set in a Wild West saloon. The main character, Rose, is a character in The Wanderer, a comic about the Old West I'm working on at the moment, to be released this year.

There are certain art styles where the main character is the center of the action and the background is a secondary consideration. But there are also illustrations where the background can be considered an extra character, because it includes additional personality or represents an iconic set. In this type of illustration you can often explore new ways to enrich a background.

Here, I'll explain the process I use to achieve a style of background that not only contrasts with the character, but is also dynamic and expressive, with a multitude of characters, expressions and different atmospheres, as well as different textures in fabrics, glass or smoke.

In this image we'll take the depth of the stage and play with the scale of the characters in the scene. The lighting offers a different perspective on how close or far they are from the light sources. Finally, we'll see some tips to generate background construction elements with the Lasso and Gradient tools, as well as create elements to depict in perspective with the Free Transform tool.

1 Sketches, setting and pose
The Wild West has many possible locations and interesting scenarios. I make several sketches trying to find what will be the most interesting or the most striking, some focused on the character and others on the environment. I settle on the idea of drawing a classic Wild West canteen area, that features several characters and some action.

2 Inking the elements
I do this part of the process quickly because everything will be covered by color and much of the inking will be lost in the following steps. I focus on closed areas, where it's easier to make selections with the Magic Wand than it will be later when detailing. I use the Lasso tool to make quick selections of areas, then fill them with the Paint Bucket tool as I'm inking away.

3 Gradient and cel-shading

I use two tones for adding light and shade before getting into color. I use the darker tone as a base, and add lighting with the lighter one. I use a Radial Gradient to apply volume to rounded parts of the image such as the face. I create light areas that later I'll fill with paint using the Paint Bucket tool, achieving an appearance similar to traditional cel-shading. Over this, I'll paint a halftone in a new layer set to 50 percent Opacity.

4 Blending tones and adding shadows

I flatten all the color layers into one and use the Smudge tool with a textured brush for smooth blending, painting with this in one direction from top to bottom and side to side. This technique gives the image softness and volume, and adds dynamism to elements such as fabric – I love drawing fabrics moving. When this is done, I add shadows by selecting areas and applying a Radial Gradient with my base color but in Multiply mode, applying this from outside to inside the image.

SHORTCUTS

NEW LAYER
Ctrl+Shift+N (PC)
Cmd+Shift+N (Mac)
Create a new layer and open a panel for you to set its Opacity, color and mode.

ARTIST INSIGHT

Allow for more Undos
I like to use Undo, mainly because often I'm not entirely sure about some brush strokes or because I feel I could make a bad color decision and would like to go back as much as possible in time to correct the error. Under Preferences> Performance, you'll find options for History & Cache, where you can increase the number of Undos up to 1,000. I prefer to use 30 undos.

5 Coloring and balance

With volumes sorted, I turn to coloring my mono image, selecting areas that will have the same color, using the Magic Wand tool. At this stage I add just large areas of color – details will come later. I duplicate the character image, add a yellowish hue (Ctrl+U) and set the duplicate layer to Multiply mode with low Opacity for an antique look. I merge all the character layers and use Color Balance to better define a final color.

6 Painting over ink

I begin adding details to black areas, such as clothing and hair. I create a new layer, which I place over the character layer, and select areas of hair and other elements with the Lasso tool. I fill these using a slightly lighter color to show the contrast. Once these are defined, I convert the layer to the final color (Ctrl+U) and repeat step four, blending to smooth for the final result. Then I merge the layer with the character's layer.

7 Highlights and details

I begin adding details to clothes and other items, giving them additional volume and shine. I add secondary highlights interacting with the character – sometimes a bit of light can make a big difference. I add light to the hair on a separate layer, then merge it to the character's layer. I use Liquify to fix physical details. On a new layer I paint her cheeks and nose in pink, then add Gaussian Blur and lower the Opacity to give her rosy cheeks.

8 Adding glasses and bottles

I don't draw bottles as such. I do a Rectangular Marquee and modify it with the Lasso tool. I fill the selection with the Paint Bucket tool, add highlights using a Radial Gradient and then Colorize (Ctrl+U). With quick selections, I create the impression of liquids inside. I use the same process for the beer, making a selection to add foam, painting with a brush and then applying Gaussian Blur. Lastly, I add a few drops on the glasses and bottles for detail.

9 Background characters and personality
The setting is a bar, so I need to add some secondary characters to the background to add life, variety of design and expression. I need characters of different ages, ethnicity and sex, each one in different dress, pose and action. A fight in the background will help ground the bar in reality, as will chairs and tables for customers to enjoy a freshly tapped beer.

SHORTCUTS
FREE TRANSFORM
Ctrl+T (PC)
Cmd+T (Mac)
Use this to quickly transform objects, changing perspective and shape.

10 Characters and color background
I paint the background characters in a similar way to steps three to five. I start with a base color, and add highlights similar to the cel-shaded ones. I add a new layer at 50 percent Opacity and paint on it with a light color to achieve a halftone. Then I apply the Smudge tool lightly in some areas. I paint characters hoping that color brings out their personalities, but I need to choose more muted and monochromatic colors, so Rose can stand out a little more.

11 Pillars and curtains
To make the pillars, I do a quick selection with the Rectangular Marquee tool, then add depth using the Gradient tool. I paint a few details, then bump up extra light for the look of a deep carving in the wood. For the curtains I make another selection, draw light areas and recolor them with Ctrl+U. I reselect the curtain area and add gradient shadows in different parts to create contrast between them. I merge both layers, then duplicate this to make the other pillar and curtains on the right.

⚙ RESOURCES

Workshop Brushes
Photoshop
custom brushes:
**HARD ROUND 3
PIXELS**

I use this brush to draw
everything! Its strokes
are thin, so they're
easy to hide on
shadows and it's great
for detailing.

**HARD ROUND 9
PIXELS**

I use this brush for
quick painting and
volumes. If I want a
smoothing effect I add
Transfer/Other
Dynamics as a preset.

TRI BRUSH

This multi-dot brush is
not for painting, but is
my brush for color
blending using the
Smudge tool.

12 Floor, staircases and chandeliers

To create a wooden floor, I draw several vertical lines
in a single layer, then use Free Transform to add perspective.
I do the same for the handrail as well. I use the same pillar as
in step 11 to create the roof and the wall, then use Bevel and
Emboss for a small border. The chandelier is done with
selections and the chains with Bevel and Emboss for quick
volume. On a new layer I add a green tone and set the layer
to Color mode.

13 Foreground characters and smoke

I add two characters in the foreground, both with heavy inks
because they're far away from my light sources. I add colors,
then draw light bouncing in a new layer and duplicate it,
adding Gaussian Blur to produce a fuzzy light. For smoke I
use the Lasso tool, fill the silhouettes with a Gradient and
use the Smudge tool to produce irregular shapes. Then I use
Gaussian Blur to remove any hardness and make it look more
ethereal.

14 Final edits to the scene

I tweak the colors a little with Color Balance (Ctrl+B)
and correct the contrast with Levels. I alter some designs
from previous phases that don't look so good now, and clean
up some inking errors. I add some extra items such as bottles
on a table and some extra bounce light on the chandelier. I
use the Blur tool in some areas, to add a slight blur and
produce a greater sense of depth. After this I can call it a
finished image. ▮

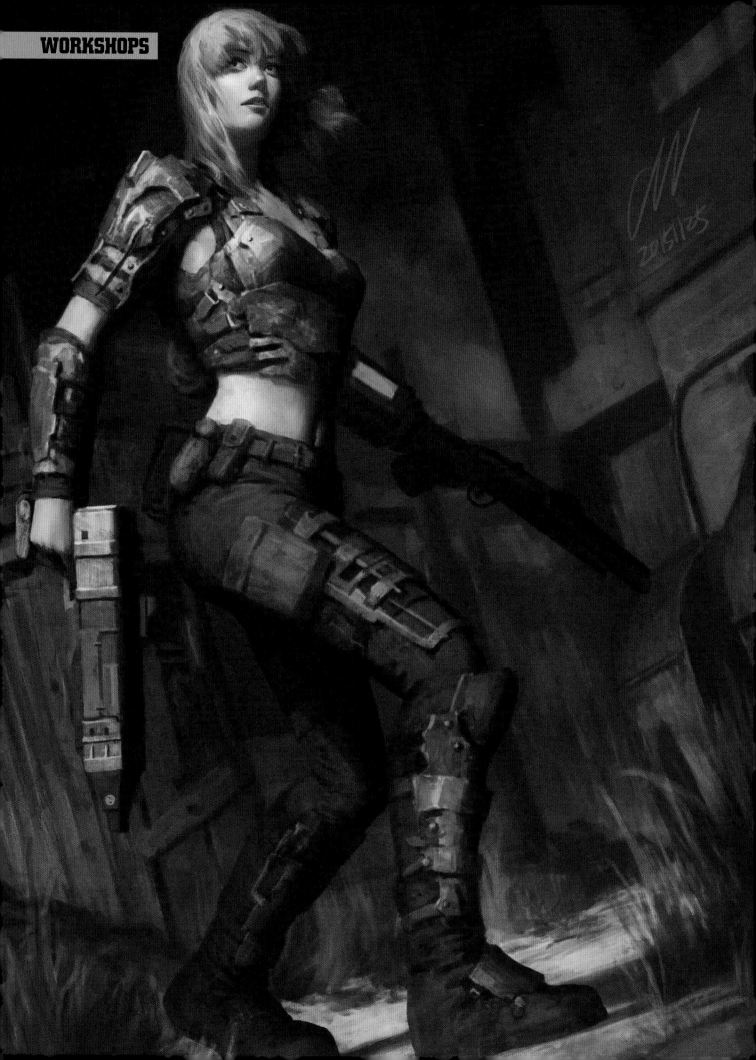

PHOTOSHOP

PAINT A HEROINE FROM A GAME

ZEZHOU CHEN introduces a relaxed way of working, as he paints a believable character who would fit into the Fallout game universe

ARTIST PROFILE

ZEZHOU CHEN
LOCATION: China

Zezhou is a freelance illustrator and concept artist who also teaches digital art techniques to students. www.zezhouchen.com

GET YOUR RESOURCES SEE PAGE 146

VIDEO AVAILABLE

ARTIST INSIGHT

Unify your shadows

Shadows are crucial for making objects in an image look consistent, especially when there's a strong lighting scheme in place. Unifying the direction of the shadows can build up the space in the scene. And making the shadows' tone consistent can enhance the presence of your light source. Treating your shadows equally will also help to make the image clearer and more effective.

The Fallout series of games has long been a favorite of mine. So when Fallout 4 came out at the end of last year I spent a lot of time playing it, immersing myself in its fascinating, nightmarish world. And it didn't take long for me to start imagining designs for my own Fallout characters.

I suppose you could say that this makes my workshop a simple piece of fan art, but there's a twist. I don't want to adopt too many references from the game. Granted, I'll get ideas for concepts from what I've seen in the game, but then I'll recombine and twist them in my mind.

When I think about my Fallout character, I actually have an image that basically conveys the same style and the feeling of the game, but the details are quite different. For example, the character's armor is a variant of Fallout's metal armor. However, I still took a direct reference from the game. It's the character's laser pistol, which is actually the same one I'm using in the game!

If you're unfamiliar with the Fallout premise, you only need to know that it's set in a world where life struggles to continue after a global nuclear war. Everything is broken and ruined. The basic idea of my painting is quite simple: I want to depict a female hero in the wasteland. I think it's interesting to put a beautiful female hero in such a brutal, desperate environment.

1 Start with a loose idea
An important benefit of painting digitally is that it's so easy to make changes. So I don't need a clear-cut plan to start an image. For example, in this workshop I just have a very loose concept, and that's enough for me to start. I'll figure out all the specific design and details during the creative process. So it's actually a very relaxed, almost random way to begin a painting.

2 Pose and composition
I'll put some clothes on the character and paint her face later. But for now I'm only looking at the big picture, considering the composition and her pose. It can be a rough and ready stage that usually doesn't look right at first. That's absolutely normal. I try several poses and different angles, before finally deciding on this one, where she's just about to turn around

WORKSHOPS

3 Correcting the pose
Now I work further on the pose, ensuring that the form, anatomy and lighting are correct. I try to find the edge of the body. This is the basis of the follow-up work. I examine the pose and ensure that it's realiztic. I often use the Flip Horizontal option when I'm trying to see what's wrong with an image. This function provides me with a fresh view of the work in progress.

4 On to the face
It's time to depict the character and details. I prefer to start from the face, because it's a key part of the image. Painting a good face is worth almost any cost. Of course, sometimes "good" doesn't mean "beautiful". In this case I'd like to give her a pretty face. At the moment I'm not happy with her facial features and expression, so I continue to work on them.

5 Setting up the lighting
I decide to use a strong spotlight on the character, which I had in mind when I was painting the face. This kind of light is also similar to the sun's light when the sky is clear. Its characteristics are that the edge between light and shadow is very clear, and the contrast between them is strong. This is perfect for bringing the character to the front of the scene.

6 Designing her outfit
An outfit is part of a character's design. It's visual shorthand for showing the role they play in their world. It can be easier to paint than a facial expression because there's little emotional element to it. I don't take reference directly from the game, but rather from memory. I use a dark tone for her clothing, ensuring there's strong contrast with her bright skin color.

7 Specific visual elements
Now I paint specific details, and describe their form and the material they're composed of. I ask myself questions as I paint: what does this bracer look like? How many metal plates are there on the shoulder? How they are mounted? This figure survives in a wasteland, so her outfit has a crude appearance. And this means I don't need to make the elements look tidy.

8 Adjusting the character
I'm happy with how the character is looking, so I plan to make only minor tweaks to her design. I adjust the figure as a whole object, starting with the lighting. I adjust the brightness all over the body to make sure all the small details are unified. I also check the pose again, and decide to adjust the position of her back leg. This makes the perspective look more natural.

9 Developing the surroundings

I start on the background by treating it as concept art, which means I can keep my brush strokes loose. I follow the logic of composition during this step. I consider how to arrange the tone, the plane and the line. The job of the background is to contrast with the foreground subject – to make the edges of the character clear and to set off the figure.

10 Exploring the setting

There are many objects that I could put into this scene: an abandoned gas station, wrecked cars, rubble, weeds and so on. The scene could be in suburbia or on a highway. It's an interesting task to choose what should be included, because there are so many combinations. I do some visual exploring and create several different variations. Then I save them, compare them against each other and pick out the best elements that will enhance the painting.

SHORTCUTS

COPY MERGE ALL LAYERS
Cmd+Opt+Shift+E (Mac)
Ctr+ Alt+Shift+E (PC)
Merge all layers into a new one, but keep the originals.

11 Making the light more dynamic

The environment's lighting should be generally the same as that on the character. But to make the image more interesting, I adjust the tone for the sky and make it even darker, to improve the contrast against the character's face. I also narrow the range of the light, which splits the foreground and the background. It now looks like a searchlight in the dark night – very dramatic!

12 Introducing specific details

I bear in mind that it's a character-led painting, rather than one depicting a grand environment, so I'm careful not to over-render the background. To enhance the scene's spatial aspect, I make the shadow darker at the front and on the figure. Doing this makes her more solid. Conversely, for the objects in the background, I weaken their shadow and the contrast.

13 Time for some polishing

The image is close to being finished. Time to relax and start polishing the details. There's nothing too serious or difficult in this stage, really. I just clean any rough strokes, make them more refined and improve the render around the character's face. I also repaint the hair and change the color of her shoes to make them more in keeping with the Fallout environment.

14 Adding the final touches

I use mostly filters and adjustment layers to do the work, including the Curves tool, Color Balance, blending layers and the Camera Raw filter that you can find in Photoshop CC. You could even put the finished work in your phone and try common filter apps such as VSCO. I just experiment and see what digital magic happens! ∎

ARTIST INSIGHT

Archive your art process

Save your painting at regular intervals, especially when you feel that you've turned a corner in your creative process. This means that you can go back and see exactly what you did. This will help you to understand how you achieved a certain look to your art. Perhaps more importantly, when you paint something you don't like, also save a copy. After a few days, seeing it with fresh eyes might reveal something of value in it.

HOW TO USE FileSilo

EVERYTHING YOU NEED TO KNOW ABOUT ACCESSING YOUR NEW DIGITAL REPOSITORY

To access FileSilo, please visit **www.filesilo.co.uk/bks-1746**

01 Follow the on-screen instructions to create an account with our secure FileSilo system, log in and unlock the bookazine by answering a simple question about it. You can then access the content for free at any time, and download it to your desktop.

02 Once you have logged in, you are free to explore the wealth of content available on FileSilo, from great video tutorials and exclusive online guides to superb downloadable resources. And the more bookazines you purchase, the more your instantly accessible collection of digital content will grow.

03 You can access FileSilo on any desktop, tablet or smartphone device using any popular browser (such as Safari, Firefox or Google Chrome). However, we recommend that you use a desktop to download content, as you may not be able to download files to your phone or tablet.

04 If you have any problems with accessing content on FileSilo, or with the registration process, take a look at the FAQs online or email filesilohelp@ futurenet.com.